"Illustrious Prince! Most Noble Gentlemen!
From childhood on, I, Titian of Cadore, have
endeavoured to learn the craft of painting,
not out of avarice, but in order to gain a modicum
of fame … And although I have been most urgently
requested in the past and in the present by
His Holiness the Pope and other gentlemen to enter
into their service, I have always cherished the wish,
as a true and faithful subject of Your Excellency,
to leave a monument to this famous city … "

Titian's petition to the Council of Ten, 31 May 1513

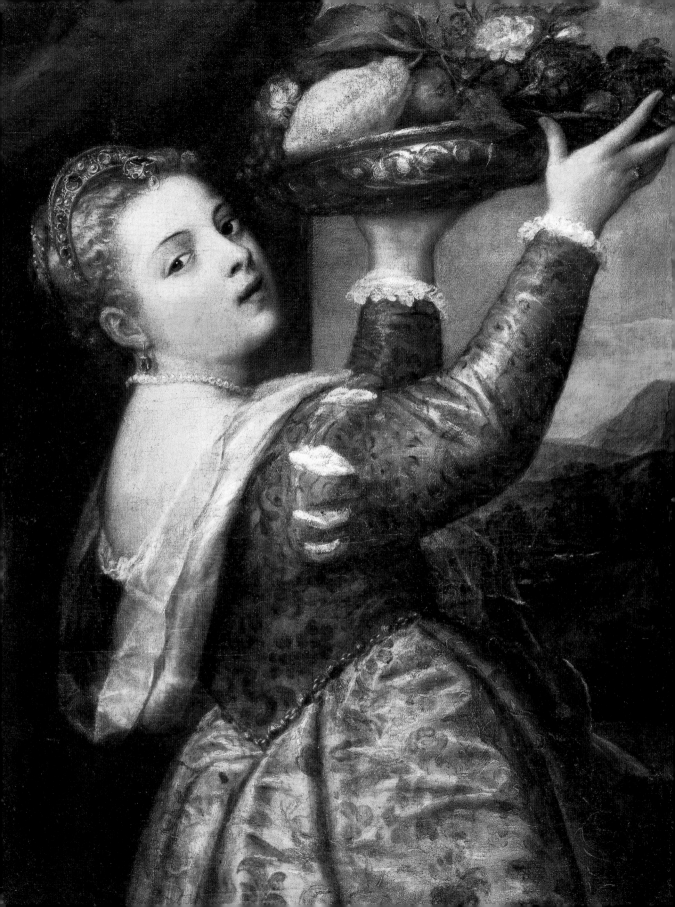

Titian

By Norbert Wolf

PRESTEL

Munich · London · New York

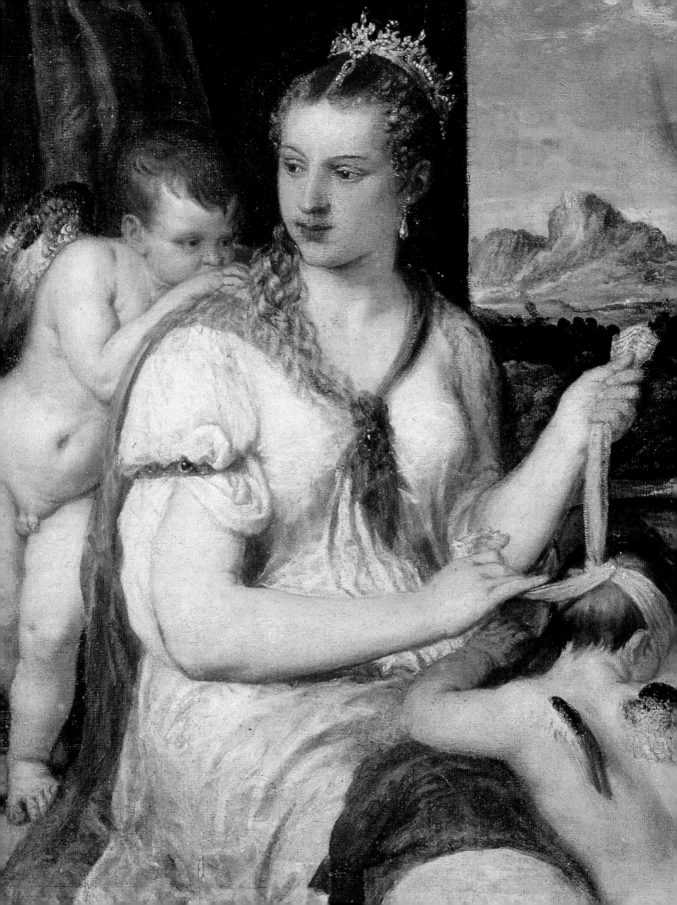

Contents

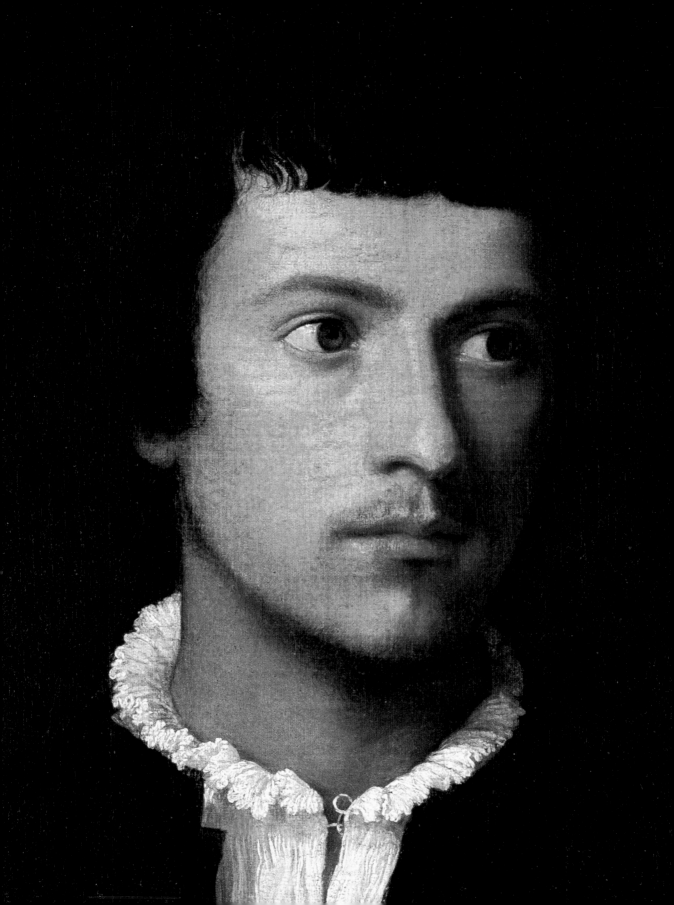

"Titian is loved by all the world because his style breathes life into the portraits and is hated by Nature for the spirits conjured by his art put the living to shame."

Pietro Aretino in a letter to Empress Isabella of Portugal on 15 January 1537

Man with a Glove (detail; see page 78), *c.* 1520

"Titian is not ailing, merely somewhat frail, but I fear that painting young ladies in all manner of poses every day exerts him more than his fragile constitution allows."

Tebaldi, Duke Alfonso of Ferrara's agent in Venice, 4 January 1522

The Andrians (Bacchanalia) (detail; see page 65), 1523

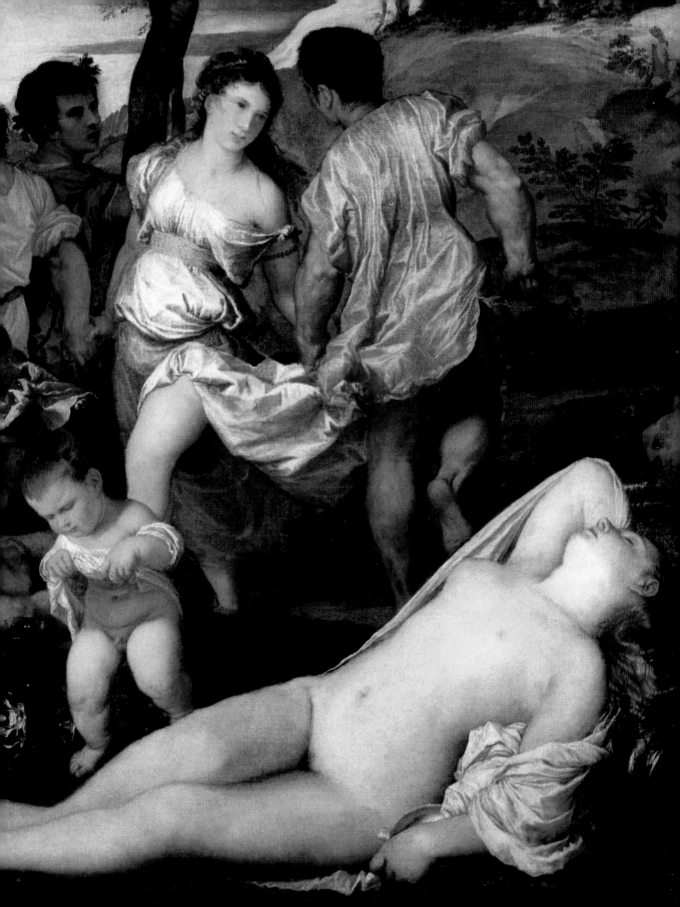

"If the grand designs I have in my mind and in my heart truly correspond with what my hands and brushes have created, then I think that I have satisfied my wish to serve Your Excellency …"

In a letter from Titian to Federico Gonzaga, the Marquis of Mantua, Venice, 14 April 1531

Man with a Glove (detail; see page 78), *c.* 1520

"Titian, dear friend, nothing is lacking in these rooms except your paintings."

Federico Gonzaga to Titian, Mantua, 26 March 1537

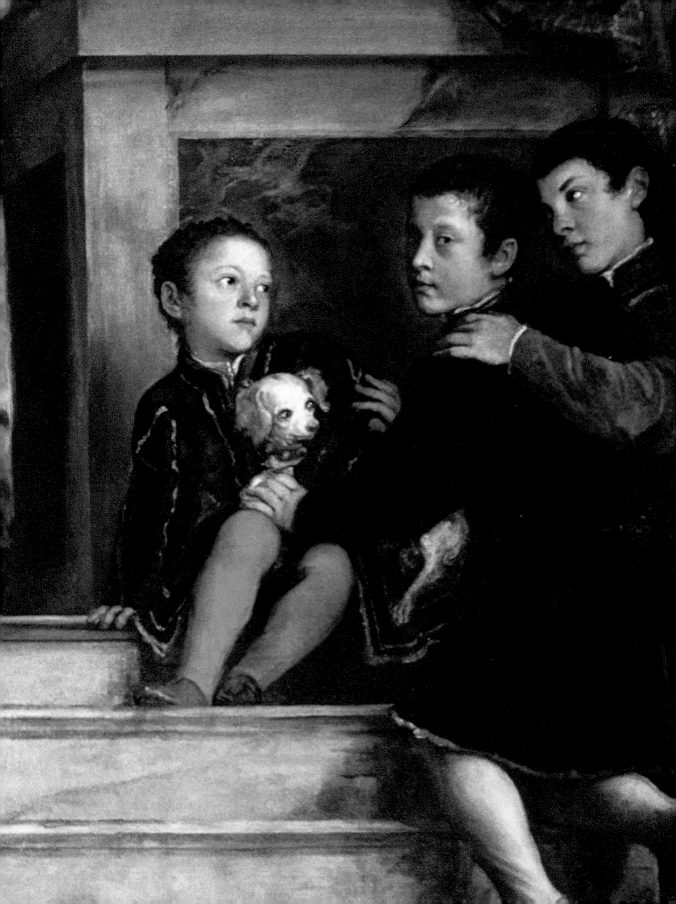

"Beneath the transparent veil of black

We glimpse celestial angels made flesh

Paint, O Titian, perfect master,

That others might see your great works."

Pietro Aretino, the author and satirist, writing about Titian and the women of Venice, 1530

Venus at her Mirror (detail; see page 95), *c.* 1550/60

"All that I have endeavoured to say is but paltry news compared to the sheer divinity of this painting (for no other word would suffice)."

Lodovico Dolce in a letter about Titian's painting, 1559

Bacchus and Ariadne (detail; see page 63), *c.* 1520–23

"Sir, I do not believe that I shall ever achieve the tenderness or skill of Michelangelo or the man from Urbino [Raphael], nor of Correggio and Parmigianino; but the natural talent I possess, which is no less than theirs, allows me to take a new direction that will make me famous for something in the same way that the others became famous for what they did."

*Titian to Charles V's ambassador, in response to the question
as to why he painted with such broad brush-strokes*

La Bella (detail; see page 92), 1536

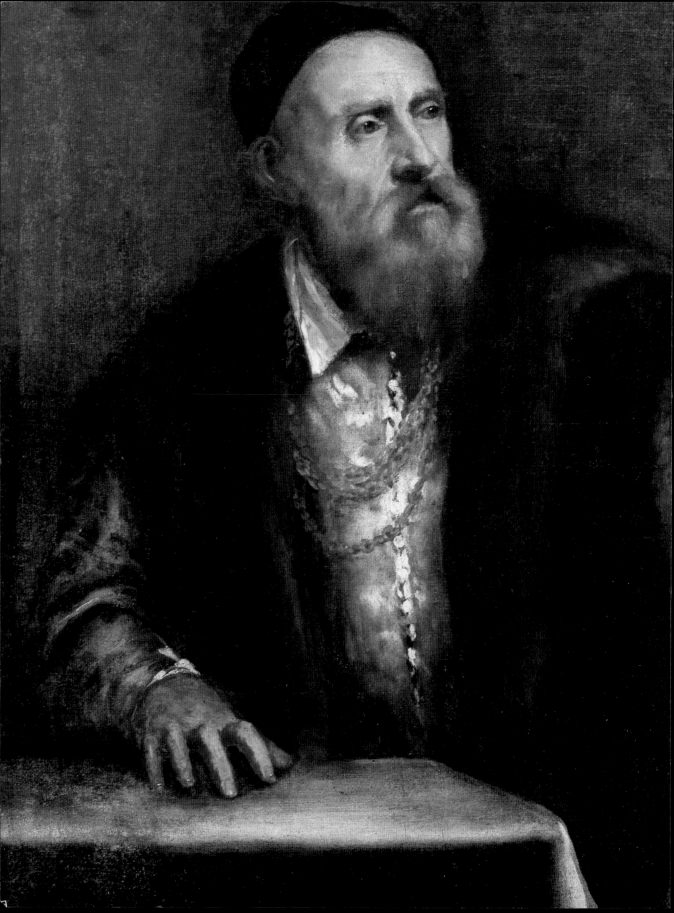

I, Titian

*"And if these gifts are not worthy of so noble a gentleman and are not by the hand of an exceptionally good master, then I beg you to accept Titian's devotion and retain the works until such time as my talents permit me to send you something that may satisfy you ...,
Your Excellency's most humble servant, the painter Titian."*

In a letter from Titian to Federico Gonzaga, Venice, 22 June 1528

The famous self-portrait of Tiziano Vecellio, better known as Titian, conceals as much as it reveals (*opposite page*). The date of the painting is disputed as is, consequently, the age of the sitter. The man we see in the picture is sixty, or perhaps even over seventy years old. He is seated at a table, covered with a green cloth, that forms a barrier between him and us. He gazes into the distance, ignoring all onlookers, albeit with a demeanour so perspicacious that it appears to encapsulate the very sentiment expressed by Titian in a letter to Federico Gonzaga, Duke of Mantua, on 14 April 1531: "If the great designs I had in my mind and in my heart really do correspond to what the hands and the brush have created ... then that would be the greatest achievement of all." In the self-portrait, now in Berlin, Titian's questing eyes seek to transpose the world of ideas from a conceptual realm to a visually tangible one. The hands that exercise his craft remain sketchily unfinished – and there is neither a brush nor any other attribute representing the tools of his trade.

Instead, Titian's self-portrait is devoted to the semiotics of his social success. There is something cosily domesticated about his little cap, but apart from that, all is prestige and reputation: the sumptuous fur robe and the four chains of gold presented to him by Emperor Charles V upon his knighthood in 1533. Titian shows himself quite consciously here as a prince of painters, as a creative visionary and as a figurehead of the upward mobility to which a master of his craft might have aspired in the age of the Italian Renaissance.

Mark Twain, an American in Europe, wrote disparagingly of such artist-princes in 1869. "And who painted these things? Why, Titian, Tintoretto, Paul Veronese, Raphael ... I fail sometimes to see the beauty that is in their productions. I can not help but see it, now and then, but I keep on protesting against the grovelling spirit that could persuade those masters to prostitute their noble talents to the adulation of such monsters as the French, Venetian and Florentine Princes of two and three hundred years ago, all the same."

Self-Portrait (detail), *c.* 1550/62 (see p. 131)

Of all the self-portraits by Titian, this is the only one, apart from the presumably later portrait in profile now in the Prado, that is attributed with certainty to the artist himself. The sleeves and hands of the Berlin version are unfinished. Perhaps Titian was undecided about portraying the rather proud pose as an expression of tension or grandezza.

The Austrian novelist and playwright Thomas Bernhard scathingly remarks in his 1985 comedy *Old Masters*: "They invariably painted a … world of hypocrisy, hoping to gain riches and fame; they all painted with this sole intention, driven by avarice and attention-seeking … ever single brushstroke, however brilliant, by these so-called Old Masters, is a lie …" The scene of Bernhard's tirade against the unholy alliance of aristocracy, church and painting took place at the Kunsthistorisches Museum in Vienna and its target, once again, is Titian, who is featured so prominently in the gallery's collection.

Titian was both a Renaissance painter of genius and a career-minded opportunist, as even his contemporaries noted – some wryly, others grudgingly.

It was not only his fellow artists who sniggered at Titian's head for business. Many of his patrons were equally bemused. The envoy to Venice from the court of Urbino described him as "the most money-grubbing individual ever created by nature; he would let himself be flayed alive for the sake of money."

Money – sometimes a lot, sometimes a little – had been a key consideration ever since Titian had become Giovanni Bellini's successor as official painter to the Republic of Venice – a situation that granted him fiscal immunity and other financial benefits. Later, much of the surviving correspondence between Titian and the court of Mantua focuses, of all things, on the projected purchase of land near Treviso. In this legally complex transaction, which also involved a Benedictine abbey, Federico Gonzaga acted as mediator, albeit unsuccessfully.

Titian also sought to ensure the financial well-being of his children. For his eldest son, Pomponio, he envisioned a brilliant clerical career that would reap rich profits. It was with this in mind that the artist approached Federico Gonzaga and his mother Isabella d'Este in 1530, when Pomponio was just five years old. The matter in question was the income from an office of the church of Santa Maria in Medole under the rule of Mantua, which had hitherto been pocketed by a conspiratorial Augustinian monk. The duke had the monk thrown into prison that same year. The incarceration seemed convenient enough, for in the autumn Titian was granted the benefice in the name of his son and travelled to Mantua to accept the post officially on 15 November 1530. But it soon turned out to be a mistake. The benefice of Medole actually cost money instead of making a profit.

It was well known that Titian was reluctant to leave Venice. In order to make Rome more appealing to him, the pope and the Farnese family took advantage of Titian's pronounced paternal worries about his reckless son Pomponio. A prosperous benefice – a 'favour', as certain church livings were called quite openly – namely that of the Abbey of San Pietro in Colle might give the boy a better footing. Titian took the bait. In the spring of 1543 he went to Bologna to paint a portrait of the Farnese pope Paul III (*opposite page*). But the promised benefice did not materialise. And so, in 1545, the artist agreed to move to the Eternal City. After completing several contracts there, the pope made him

Portrait of Paul III, 1543

In the spring of 1543 Paul III Farnese commissioned this portrait by Titian which is now in the Museo Capodimonte in Naples. For the sitting, the artist traveled to Bologna, where the Pope was meeting Emperor Charles V. This now famous painting was created within a short period between the end of April and the end of May. Pietro Aretino wrote enthusiastically to Titian of the "miracle that your brush has achieved in the portrait of the Pope" – though he probably never actually saw it.

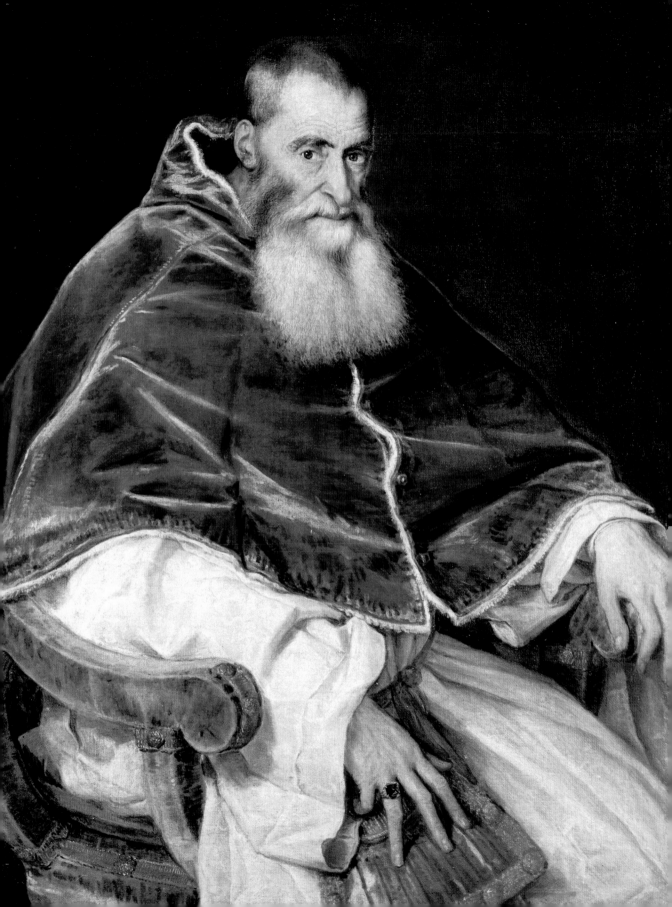

an honorary citizen of Rome – an accolade that cost nothing. By the end of May 1546, Titian had finally realised that he was nowhere near achieving his aim. All the pope had provided for Pomponio was the meagre parsonage of San Andrea in Favaro Veneto within the bishopric of Treviso, with an annual income of only twenty-four ducats.

Many years later, Titian finally admitted that Pomponio was not suited to a clerical career. But this did not mean that he was willing to forgo his family's rights to the benefice of Medole. In 1554, he asked Duke Guglielmo Gonzaga to transfer it to one of his nephews. In a rather whining tone, he also demanded the refund of all costs. In 1569, the elderly Titian threw his energy into assisting his second-born son. He petitioned the Venetian authorities to transfer his *sensaria* – a guaranteed state pension granted more than fifty years previously that produced an annual income of 100 ducats as well as noticeable tax benefits – to Orazio, who, unlike Pomponio, had been a lifelong support and reliable assistant to his father.

Did such activities, of which there are many more examples, earn Titian the reputation of an irritating petitioner to the courts? Occasionally, yes. But for the most part, it is reported that he acted with *noblesse*, wit and great diplomacy in his dealings with the ruling powers.

On 26 January 1523, for instance, the Mantuan envoy Giambattista Malatesta informed the Marchese Federico that Titian, who would soon be received at the court of the Gonzaga, was an artist of outstanding talent (*excellentissimo nell'arte sua*) and that, fortunately, he was also a person of pleasant and modest disposition. *Modesto* meant that the painter was aware of how to behave appropriately towards the social elite. Acceptance at court implied a certain flattery typical of that time. In a letter to Duke Alfonso of Ferrara on 1 April 1518, Titian wrote that he had, with his brush, merely given form to "the spirit – that is to say, the greatest part – conveyed by Your Highness". The idea of an artist regarding himself merely as an organ of the patron and as a recipient of his instructions was not considered fawning at that time, but merely seen as an appropriate expression of modesty and politeness.

One episode that is often related, though it is hard to say whether it is truth or fiction, turns the tables. It is said that Emperor Charles V, to the dismay of his courtiers, once picked up Titian's brush from the floor when the elderly artist had dropped it: the worldly ruler showing reverence to the sovereign of the realms of art! The message here is that even in his own lifetime, Titian had been deified. Not for nothing did Paolo Giovio, in a dialogue penned before 1523, rank the Venetian artist Titian alongside the luminaries (*praeclara lumina*) of Central Italian art – Leonardo da Vinci, Michelangelo and Raphael. Barely a generation later, Lodovico Dolce was to become an even more eloquent defender of his art, speaking of Titian's 'divine brush' and seeing in him the perfection of painting (as opposed to sculpture, in which Michelangelo was still famed as the *divino*).

Madonna of the Rabbit (detail), *c.* 1529

The exquisite background landscape is redolent of the region around Pieve di Cadore, where Titian was born.

The Old Master of Venice had become a 'classic' in his own lifetime – and with that the focus of inscrutable mystification. He himself had had no small part in weaving the tapestry of his legend.

Titian is said to have reached the grand old age of one hundred years. The death register of the parish of San Canciano in Venice, which is admittedly not entirely reliable, states that the painter, who died on 27 August 1576, had been born in 1473. In letters to Philip II of Spain, who was later to become an important patron, Titian constantly amends his age upwards, fuelling the legend of the centenarian wrested from life while working at his easel. But there is much to suggest that the chronology is wrong. Lodovico Dolce, who, in his *Dialogo della pittura* published in Venice in 1557, puts the year of Titian's birth at some time between 1488 and 1490, seems more plausible. Whatever the truth of the matter may be, Titian certainly enjoyed great longevity by the standards of his day, when the average life expectancy was just twenty-six years.

One thing is certain: Titian was born in Pieve di Cadore in Piemont. Today, it is a small provincial town of some 4,000 inhabitants where the humble (alleged) birthplace of the artist was declared a national monument in 1922. Titian's father, Gregorio di Conte Vecellio, was a soldier and a respected member of the local council. He also appears to have been a supplier of timber to the Venetian docks. The local connection is reflected in the relatively unusual baptismal name of Titian, which he also passed on to his second-born son. The name is derived from Titianus, a saint and seventh-century bishop of Oderzo in the Veneto region who was revered mainly in Friuli and the area around Cadore from the ninth century onwards. The Vecellio family tree includes many soldiers, notaries and minor officials – but no artists. It is believed that Titian went to Venice at the age of nine with his brother Francesco and completed an apprenticeship there with the mosaic artist Sebastiano Zuccato before transferring to the studio of Gentile Bellini and later moving to the studio of Gentile's brother Giovanni Bellini, the *grandseigneur* of Venetian painting.

It was not long before he met Giorgione, who was to enjoy a meteoric rise to fame before him. A brief visit to Venice by Leonardo da Vinci is documented in early 1500, but it is unlikely that he would have paid much attention to the young Giorgione. Nevertheless, in some way or other, Giorgione must have become familiar with Leonardo's *sfumato*, his painterly blurring of contours. Giorgione adopted it without giving up the sumptuous luminosity of his thickly-applied paints. Small wonder that Titian wanted to learn the studio secrets of Giorgione, the true founder of the painterly style that has come to be known as the Venetian school. Around 1507/08, it is thought, the two joined forces for a while, though they did not share a workshop with assistants and apprentices.

Titian was quick to adopt Giorgione's achievements and imbue them with his own style. Indeed, since the seventeenth century, it has been difficult to distinguish between the works of Giorgione and the early works of Titian. Accordingly, the enigma

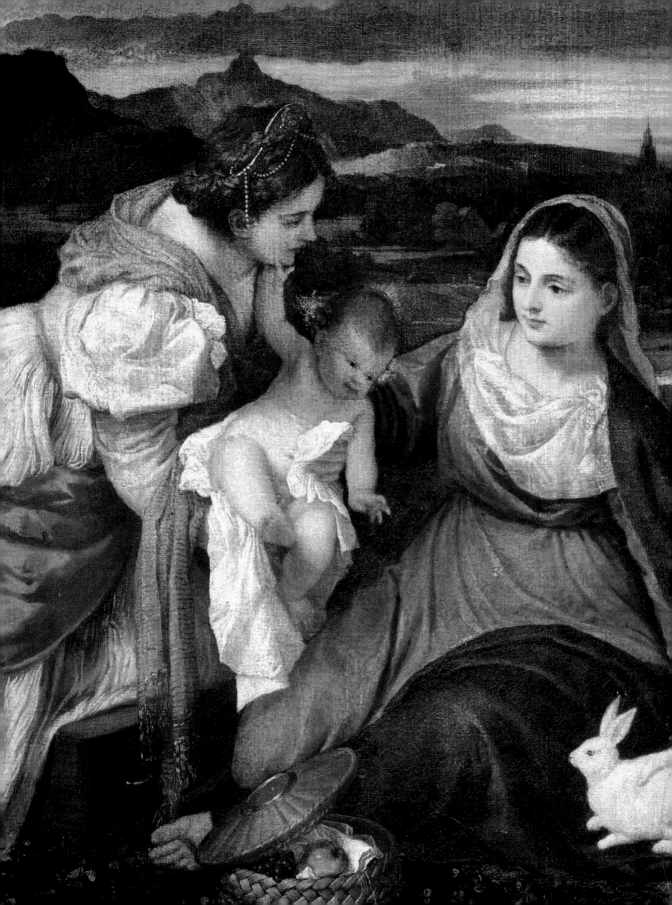

Madonna of the Rabbit, *c.* 1529

Some scholars believe that the figure of
Saint Catherine to the left of the Virgin's is
a portrait of Titian's bride Cecilia with her
youngest son. The shepherd on the right
has occasionally been identified as Fede-
rico Gonzaga. This wonderful painting,
cropped on both sides, was probably pre-
sented to Cardinal Richelieu as a diplomatic
gift from Vicenzo Gonzaga some time
between 1624 and 1627. Gianlorenzo Ber-
nini saw the painting in the collection of
the French cardinal. It was sold to Louis XIV
in 1665 and has been in the Louvre since
1785.

The Concert, *c.* 1510/12

This enigmatic work is typical of Titian's early Venetian paintings which bear strong affinities with the works of Giorgione. It is widely regarded as one of Titian's early masterpieces.

surrounding the œuvre of Giorgione and the early work of Titian has been shrouded in mystery and uncertainty. For instance, *The Concert* in the Palazzo Pitti (*above*) was regarded as a work by Giorgione until well into the nineteenth century, before its attribution to Titian became widely accepted.

The myths disseminated by Giorgio Vasari have proved particularly hard to dispel – probably because their subversive aims were cloaked in the garb of serious art history. Vasari wrote his biography of Titian for the 1568 Giuntina edition of his *Lives*, having devoted only a few marginal asides to this Venetian artist in his first edition of 1550.

Vasari tells us that he, together with Michelangelo, visited Titian in 1545 while he was in Rome at the invitation of the Farnese family. On the way home, as he reports, Michelangelo praised Titian's handling of colour but criticised what he saw as the inadequate teaching of draughtsmanship in Venice. He felt that Titian's painterly style betrayed a superficial observation of nature without pursuing the higher ideal of *disegno* – the line guided by artistic reason. By maintaining that Titian was brilliant only as a

colourist, but otherwise practiced the simple representation of nature bereft of any intellectual order, Vasari degraded him to a painter of lowly education who, like his mentor Giorgione, was lacking in art-theoretical reflection. This, according to Vasari, was what distinguished him from the illustrious trio of Raphael, Michelangelo and Leonardo. The fact that there are hardly any surviving statements by Titian himself about his own work or that of other artists also prompted Carlo Ridolfi to dismiss the intellectual capacity of the painter, some seventy years after his death, with the words: *non fosse di molta letteratura* as *quantité négligeable*.

These pseudo-rational critiques of Titian that compared him so unfavourably with the Renaissance painters of Central Italy were to have lasting repercussions, even though Titian, according to other eye-witnesses of his day, was perfectly willing and able to discuss his works in a broader context – as Vasari himself ultimately conceded, albeit reluctantly.

Early art historians were as mystified by Titian's late work as they had been by the beginnings of his œuvre. It provided the construct of a weary genius withdrawing into isolation in the autumn of his life – in spite of the fact that many letters have survived documenting Titian's sociability and, above all, his willingness, even in old age, to take on major projects. In June 1574, for instance, he received visits from the designated King of France, Henri II and the Spanish painter Sanchez Coello, who found him a gracious host. Such facts were long ignored in view of a magnificent late work that so conveniently evokes the desired paradigm of the reclusive artist. The work in question is his profoundly moving *Pietà* (see pp. 29, 30). The Virgin – beside her the wildly lamenting Mary Magdalene – sits with the body of Christ on her lap before an aedicula flanked by the statues of Moses and a sibyl. The sibyl bears a cross indicating the Passion, which identifies her as a Hellespont seer as confirmed by the inscription on the socle. The crown of thorns she wears would indicate the Delphic Sibyl. The uncanny arm at the foot of this figure refers to the hand that struck Christ at the beginning of the Passion and is an attribute of the Tiburtine Sibyl.

On the lower right Titian has placed a small devotional panel in front of the escutcheon presented to him by the emperor. This panel also shows a pietà: the Virgin with her dead son hovers on a cloud before two kneeling figures usually identified as Titian and his son Orazio. The elderly man, probably Saint Jerome, kneeling in front of Christ above the devotional panel, is presumably a self-portrait of the artist. The figure of an old man seeking to grasp the death of his Redeemer may well represent the octogenarian painter who determined that this painting should be placed above his tomb in

Pietà, 1570–76

QUOD TITIANUS INCHOATUM RELIQUIT / PALMA REVERENTER ABSOLVIT DEOQ. DICAVIT OPUS. The inscription tells us that this unfinished work by Titian was reverently completed by Palma il Giovane and dedicated to God.

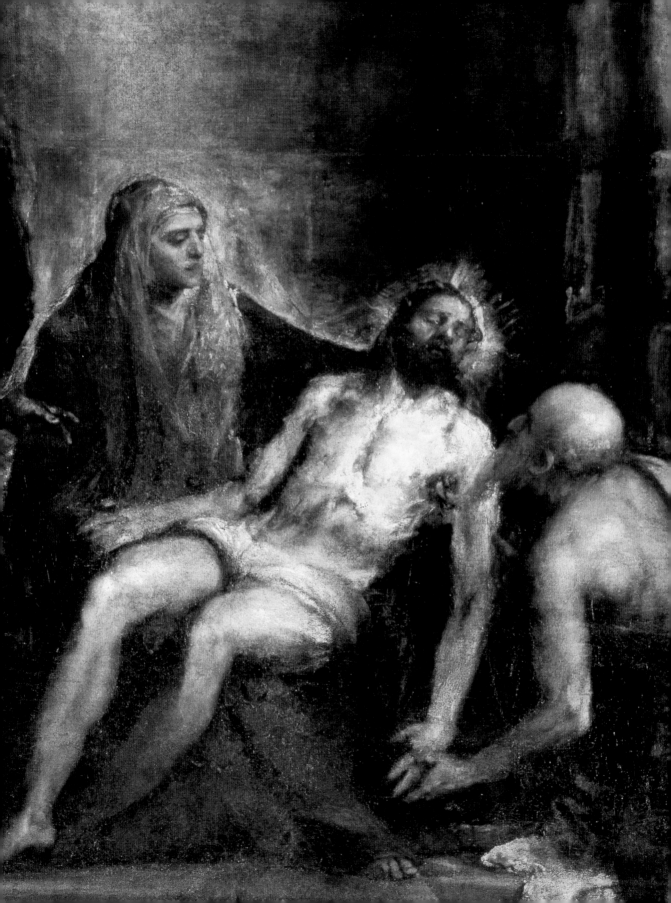

the parish church of his home town. Titian worked on this visual *ars moriendi* until his dying breath – a legend as touching as any cloying picture of death.

In actual fact, the painting did indeed leave the easel and the fictitious solitude of the studio. Even the illusionist mosaic in the niche showing the pelican tearing at its breast is a conventional symbol of Christ's sacrifice on the cross and the sacrament of the Eucharist. The canvas was intended for an altarpiece in the Frari church. It is reliably documented as having hung above this alter, but was removed by the Franciscans, perhaps because of its bold iconography and because of what they may have regarded as its imperfect painterly execution. On 27 April 1575 the monks returned the painting to Titian. After his death, it passed from his estate to the painter Palma il Giovane, who, according to restorers, undertook some minor retouching.

Titian was neither a bohemian artist, as Giorgione may have been, nor an outsider. Not even as an old man. He was a public figure. Accordingly, the Venetians planned a magnificent funeral ceremony for him in 1576 that was, as we might say today, aimed at putting a spin on Titian to rival the cult of Michelango in Florence. But the horrors of the plague put paid to their ambitious spectacle. Was Titian, who died on 27 August 1576, yet another victim of this dreaded epidemic that had already felled a quarter of the population? His final resting place was not, as he had wished, in the family chapel in Pieve di Cadore, but at the *altare del Crocefisso* in the Frari Church where his *Pietà* had once hung. This is odd, considering that the bodies of plague victims were not allowed to be interred within the city boundaries. Does this mean that those sources which state that Titian's death was due to the infirmity of old age are actually correct?

His was truly an enigmatic end. And it was to have one final and violent cadence: after the death of the Old Master, burglars broke into his empty home and, according to police reports, stole *quadri innumerabili di non picciol valore* ('several pictures of no small value').

Pietà (detail), 1570–76

There has been much debate about the identity of the elderly man kneeling before Christ. He is generally regarded as St Jerome and as a self-portrait of the artist himself, by then in his eighties, who has used this role to portray himself as a reverential penitent.

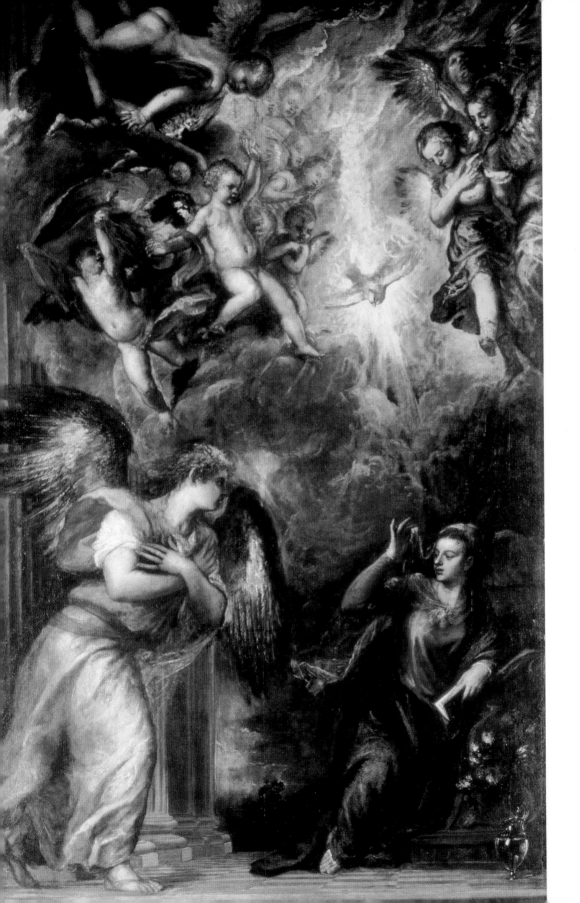

Painter of the Serenissima

"In the portrayal of all that can be seen, your hand rivals only Nature, so keenly does it imitate the spirit within each object, so that Nature itself begins to doubt which of you is greater and better."

Pietro Aretino in a letter to Titian

The *Annunciation* (*opposite page*), painted by Titian for the Church of San Salvador in Venice in the 1560s, possesses a symbolism that appears rather odd to us today. It represents the virginal body of Venice itself: *Venezia, sempre virgine*. Traditionally, the city of Venice was founded in the year 421, on 25 March, the Feast of the Annunciation. For this reason the south side of the Rialto Bridge bears images of the archangel Gabriel and the Virgin. Venice's lack of a city defence wall and the fact that this 'Queen of the Seas' had never been conquered were typically seen in the sixteenth century as echoing the virginity of the Queen of Heaven. Religious sermons and political propaganda described Venice as a 'Marian body', with Rialto as its lap, and even compared Rialto to the womb of the Virgin bearing the Redeemer.

San Salvador was a prominent church where the patricians of Venice were interred in magnificent tombs. Like the city itself, the church had been founded on the Feast of the Annunciation, in 1507. Each year, sermons were held underlining the significance of this date.

Titian's four-metre-high altarpiece of the Annunciation is teeming with dynamic movement. The heavens are parting to cast a dazzling light on the scene below which, though it occupies only a small arena, is set against a backdrop of seeming infinity. From the left, the Archangel Gabriel rushes towards the Virgin Mary at her prayer stool. The radiant flesh tones of the other angels melt with the golden hue of the clouds and the reddish glow of the background. The Marian colours of red and blue stand out against this fiery crescendo. Vasari dismissed the sketchy brushwork as an indication that the painting was unfinished. This was refuted by the art writer Carlo Ridolfi in 1648 by way of an anecdote in which he relates that Titian, on being asked to complete the painting, merely added to it the words *Titianus fecit fecit* – his double use of the perfect tense underscoring the perfection of the work itself. Infrared photographs have since shown the word FACIEBAT underneath the double FECIT and it is now assumed that the wording was changed sometime in the seventeenth century.

Annunciation (detail), *c.* 1563/66

The sketchy and even at times almost abstract handling of colour in this painting caused a certain amount of consternation even in the sixteenth century. Two steps at the lower edge of the painting merge the imaginary space of the painting with the real space of the church where this work still hangs. Titian has placed his signature at the interface between the imaginary and the real. A further inscription (IGNIS ARDENS NON COMBURENS) indicates that the vase on the ground is a Marian symbol.

33

Whatever the truth of the matter, the altarpiece was certainly not a *non-finito*. Titian quite deliberately used an almost abstract tapestry of colour and light to create a sense of dynamism. The visible brushwork and shimmering daubs of paint seem to mirror the splashes of colour and light on the façades and canals of this city that compared its urban body to the radiant body of the *Maria annunciata*. Never was an artist predestined as Titian was to paint the brilliance of Venice, even the brilliance hidden in the shadows.

Titian absorbed the atmosphere of this unique city with all his senses. He loved the place, according to his acquaintance, the sculptor Francesco Sansovino (the son of his close friend, the artist Jacopo Sansovino), who published a description of the city in 1581 entitled *Venetia città nobilissima et singolare*.

In the year of Titian's death, the population of Venice was an estimated 180,000 – including the 11,000 whores and courtesans mentioned by the historian Marino Sanudo. By the standards of the day, Venice was truly a cosmopolitan city, a maritime power that held sway not only over the coasts of the Eastern Mediterranean, but also the *terraferma* of the fertile Northern Italian plains of the Po, Adige, Brenta and Piave, from Udine in the east to Bergamo and Brescia in the west, including Padua, Verona and Vicenza.

But in December 1508 the ambitiously expansionist Serenissima faced an existential threat: France, the Holy Roman Empire, the Pope and several Northern Italian states joined forces against Venice in the League of Cambrai. Their coalition troops invaded the *terraferma* and gained victory a year later in the Battle of Agnadello. Although the Venetian government succeeded in weakening the opposition, the Republic remained in a state of war until 1517. On the face of things, however, little seemed to have changed in the city itself. What really affected everyday life was the recurrent outbreak of plague. The eye-witness Rocco Benedetti reports of the great epidemic of 1576–77 that Venice became a wasteland where grass began to grow in the city squares. He noted that the sick were abandoned to their fate or languished in unspeakable conditions in the Lazzaretto Vecchio. One of them was Titian's son Orazio.

We can only imagine how overwhelmed Titian must have been when he had first arrived in Venice some eighty years before from his small mountain village in Friuli. He was certainly not the only provincial incomer among the artists there. Indeed, relatively few Renaissance painters – such as the Vivarinis, the Bellinis, Carpaccio, Crivelli, Basaiti, Jacopo de' Barbari and Tintoretto – were actually from Venice itself. Most of the artists to whom the Queen of the Adria owes her image as the home of the great colorists actually came from the *terraferma*.

The region of Treviso was the birthplace of Giorgione (from Castelfranco), Cima (from Conegliano), Paris Bordone and Bissolo (both from Treviso itself), to name but the most famous. Bernardo Licinio, Giovanni Cariani, Palma Vecchio and Andrea Previtali came from Bergamo and Lorenzo Lotto was born in Venice to parents who had moved there from Bergamo.

Venus Blindfolding Cupid (detail), 1565

The painting (see p. 135) shows Venus is blindfolding the little cupid (Amor) who is leaning on her lap while a second cupid, who is not blindfolded, leans over her shoulder. At the same time, two maidservants are bringing the weapons of love. While Venus is the focal theme of this mythological composition, the beautifully painted background (*above*) of rugged cliffs recalls Titian's home in the foothills of the Dolomite mountains.

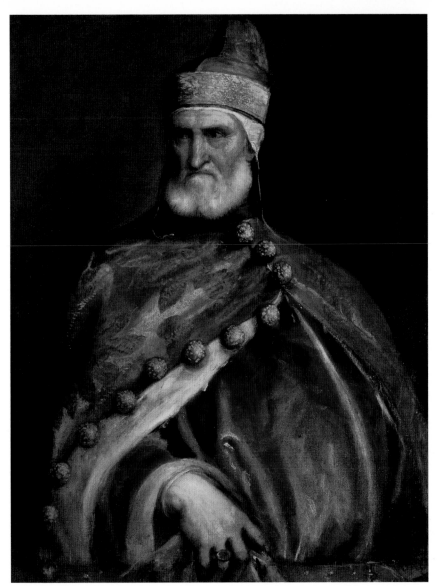

Portrait of Doge Andrea Gritti,
c. 1545

He was born to rule – or so it is said
of this man who so energetically
defended the position of power that
Venice held between France and the
Holy Roman Empire. There is some
uncertainty as to the actual date of
this magnificent painting by Titian
which is now widely regarded as a
posthumous portrait created sever-
al years after the death of the Doge.

By the turn of the fifteenth to the sixteenth century, the Venetian art scene was gain-
ing the kind of recognition to which Florence had long been accustomed. Sculptors and
painters were no longer regarded as craftsmen, but as representatives of an *ars liberalis*
on a par with poets and philosophers. What is more, beginning with the appointment
of Giovanni Bellini on 26 February 1483, La Serenissima introduced the post of an offi-
cial state painter who was exempt from the restrictions of any guild and had the task of
providing a portrait of the Doge when required. Titian was to paint no fewer than six
official portraits in the period between 1521 and 1554. Titian's rise to the heights of
courtly circles in his capacity as official state painter fully accommodated his desire to
shake off the stigma of the lowly craftsman. In 1576, he would proudly recall that
Emperor Charles V had admitted him 'to the ranks of his most loyal servants'.

Pages 36/37
Vendramin Family, *c.* 1543–47

The relic of the cross, originating in Con-
stantinople, was donated to the Scuola
Grande di San Giovanni Evangelista by the
King of Cyprus in 1369. At the time, the
Scuola Grande was headed by a certain
Andrea Vendramin who is said to have
saved the relic when it was thrown into a
canal – a legend already painted by Gentile
Bellini. The patron of this work by Titian
was also named Andrea. He can be seen
kneeling on the left.

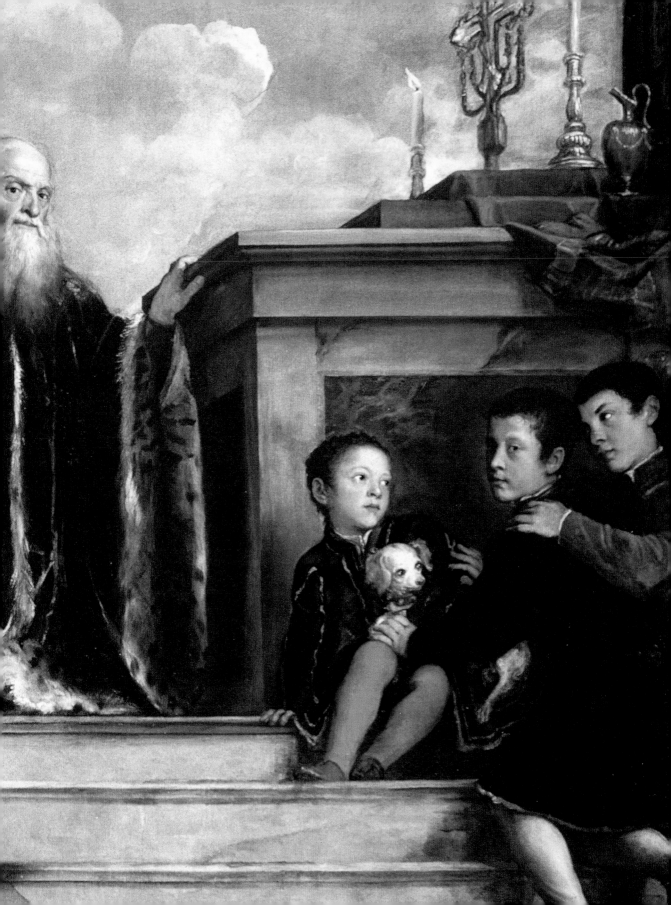

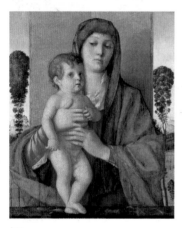

Unfortunately, we have little information about Titian's early work. This is true even of his apprenticeship to Giovanni Bellini, which left certain traces, as in his painting of the *Gypsy Madonna* (*left*). The first major work by Titian, though its exact date is uncertain, is his *Pesaro Altarpiece* in Antwerp (*opposite page*), which also seems the closest to Bellini's style. His collaboration with the flamboyant and brilliant Giorgione appears to have had more of an impact. It began with a terrible event in the city's history.

On the night of 27 to 28 January 1505, fire engulfed the Rialto district, destroying the Fondaco dei Tedeschi, the seat of the German trading company. Rebuilding was quickly undertaken and by 1507 the decorative work had begun. Giorgione provided the frescos for the façade overlooking the Canal Grande, while the south façade along the Merceria and the east façade towards the Campo were undertaken by Titian and completed by March 1509. Only fragments of these wall-paintings now survive (*opposite page*). Giorgione was already an acknowledged artist. Titian was less well known. Both men, however, seized this opportunity of demonstrating their skills in the centre of the city. The story that Giorgione broke off his friendship with Titian out of jealousy is completely fabricated. In fact, their collaboration was to blossom into a fruitful symbiosis. In 1508, Giorgione had started work on his *Venus*, which is now one of the greatest treasures in the Dresden Gemäldegalerie. Although most art historians agree on the authorship of this painting, there are some who believe it was done entirely by the hand of Titian.

Marcantonio Michiel wrote in 1525 that Titian reworked a *Venus* by Giorgione in 1510 following the latter's early death. Was it the Dresden *Venus* (see p. 89)? X-ray photographs indicate that Titian may well have painted the brown area of earth in the upper left, the landscape background, the two brownish trees and the upper fortifications on the right, as well as the sumptuous drapery of the white sheet. Shortly before 1837, a figure of Cupid at the feet of the sleeping Venus was painted over in the Dresden gallery, which had acquired the painting in 1699. If we take into account the presence of this figure, we can deduce that the painting was intended as a visual wedding poem. This hypothesis is further supported by the fact that, of only two other examples of this particular iconography to be found in the Venetian painting of the sixteenth century, one is Titian's *Sacred and Profane Love* (see pp. 52/53).

The attribution of the *Concert champêtre* (see p. 40) dating from around 1510 could also fill a library – and not just since Manet paraphrased this bucolic scene of two naked women and two music-playing men in his scandalous *Déjeuner sur l'herbe* of 1863. Giorgione's authorship of the painting was first called into question in 1839. Gradually,

top
Gypsy Madonna, *c.* 1510/12

This portrayal of the Virgin has become known as the Gypsy Madonna due to her strikingly dark complexion. The harmoniously triangular composition of the Virgin and Child – slightly to the right of centre and balanced on the left by an atmospheric landscape – together with the subtle handling of colour creates a dreamlike mood in which the young Titian seems to have been inspired by his teacher Giovanni Bellini and colleague Giorgione.

above
Giovanni Bellini, **Madonna degli Alberelli**, 1487, mixed media on panel, 74 x 57 cm, Gallerie dell' Accademia, Venice

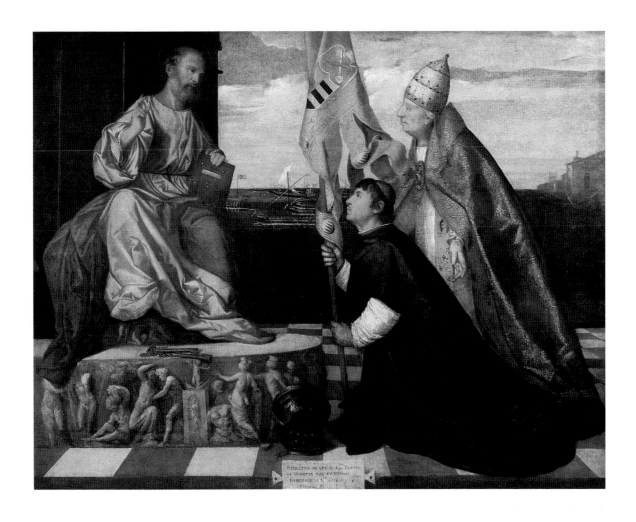

above
**Pope Alexander VI Presenting Jacopo da Pesaro
to Saint Peter**, 1503/07

Borgia Pope Alexander VI presents Jacopo Pesaro to
St Peter as a defender of Christendom against the Turks
(the seascape in the background alludes to his great
maritime victory against the Ottomans). Pesaro was no
ordinary Venetian noble; his special status is reflected
in the grand stately processions of the clerical hierarchy
in which Il Baffo (as he was known in Cyprus due to his
bishopric of Paphos) took the place of honour behind the
Doge, following the foreign dignitaries but before the
members of the Grand Council.

right
Judith or **Allegory of Justice**, *c.* 1508/09

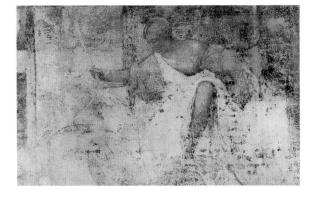

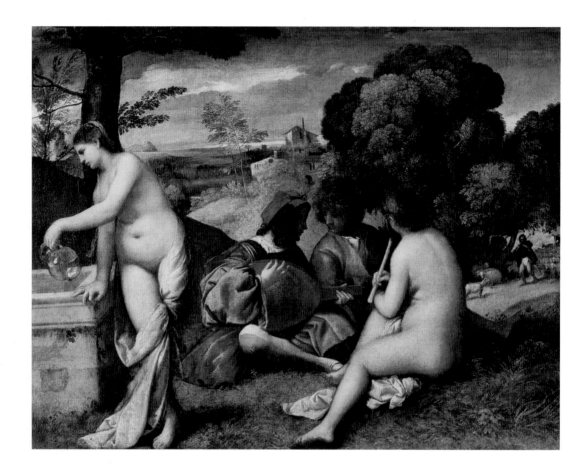

Giorgione or Titian, Concert Champêtre, *c.* 1510

This painting is probably the most famous example of the difficulty ascribing works to either Giorgione or Titian.

Il Bravo, *c.* 1515/20

This highly celebrated close-up is utterly compelling not only in its dramatic action – the murderer, or *bravo*, grabbing his victim – but also in the enigmatic way we are left in the dark as to the why, the where-fore and the aftermath. Titian's author-ship seems more likely than Giorgione's because of the extreme sense of tension in the handling of light and the juxtaposition of impasto paint with translucent scum-bling.

Titian came into the running. The enigmatic scene with its allusions to humanist music theory suggests the compositional approach of Giorgione, while the sensuality of the painterly technique, most modern art historians believe, is indicative of Titian. The compromise solution – that Titian merely made some later amendments, as in the case of the *Venus* – has currently fallen out of favour.

Some of the most fascinating Venetian paintings created up until Giorgione's death in 1510 are surrounded by uncertainty as to whether the painter from Pieve di Cadore or the painter from Castelfranco might be the author. Apart from the two examples mentioned above, these include *Christ Bearing the Cross* in the Scuola di San Rocco, *Ariosto* (see p. 120), *La Schiavona* (see p. 55), *The Concert* in Palazzo Pitti (see p. 28), *Il Bravo* in Vienna (*opposite page*), *The Tribute Money* in Dresden and several others. Present-day art historians, faced with these dilemmas, tend to find in favour of Titian, thereby considerably reducing the scope of Giorgione's œuvre.

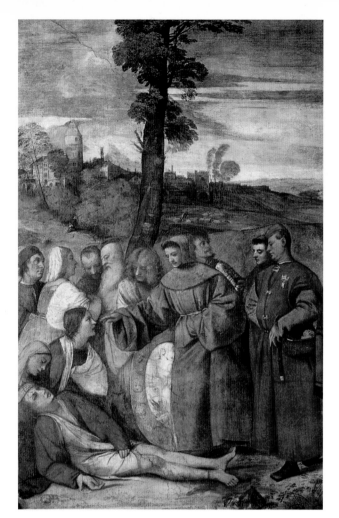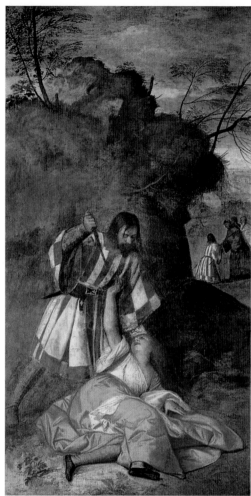

Frescos of the Scuola del Santo in Padua,
1511

In one of his earliest major commissioned works, a Paduan wall-painting, Titian was required to portray the miracles wrought by St Anthony. The painting on the left shows the miraculous healing of a young man – his foot, having been cut off in a fit of anger, has been restored under the blessing of St Anthony in his Franciscan habit. The following scene shows the jealous husband stabbing his wife in the foreground, with St Anthony in the background on the right bringing the murdered woman back to life at the pleading of the remorseful man.

We find ourselves on firmer ground when we follow Titian on his journey to Padua in the spring of 1511. On 1 December 1510, Nicola da Stra, the local representative of the Brotherhood of Saint Anthony, had visited the artist in Venice and had commissioned him to execute three frescos for the chapter room (*scoletta*) of the Scuola del Santo. This is the earliest written documentation in which the name Titian is mentioned. He was asked to create scenes illustrating the life and work of Saint Anthony (*above* and *opposite page*).

A number of precursors are mentioned, including marble reliefs by Tullio Lombardo. It is also possible that the two-hundred-year-old frescos by Giotto in Padua provided further inspiration to create a visual language that combines poignancy with monumentality while placing a few striking figures within a sparse setting. In the fresco portraying the jealous husband, the woman prostrate on the floor echoes the figure of Eve in Michelangelo's Sistine Chapel ceiling depiction of the Fall. As it is unlikely that Titian travelled to Rome at that time, he must have known the composition from some other source.

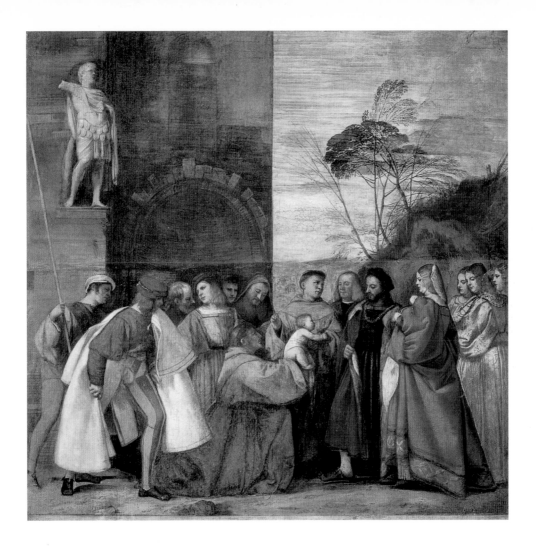

In 1513, Titian received a tempting letter. The humanist Cardinal Pietro Bembo invited him, on behalf of the pope, to travel to Rome, where he could pit his genius against that of Raphael and Michelangelo. Titian, however, remained true to Venice. He had only recently applied to become official painter to the state, a position still held by his teacher Bellini. He had offered to paint a battle scene on the south wall of the Sala del Maggior Consiglio in the Doge's Palace (see p. 44) – not omitting to mention that he had already received invitations from the pope and other princes, but that he preferred to serve the Republic first and foremost.

Titian requested a lucrative, guaranteed state pension and two apprentices to be paid for by the Salt Office. Bellini protested. In March 1514 the contract was annulled. Now it was Titian who protested against the intrigues of those "who do not wish to see me as their rival." After the death of Bellini, and having at last taken over his position, Titian took little interest in this ambitious project. The battle painting (destroyed by fires in 1574 and 1577) was taking shape so slowly that he was accused in 1537 of having barely begun. When a rival appeared on the scene in the Doge's Palace in the person of

The almost perfectly square scene shown portrays an only marginally less sensational event: St Anthony briefly grants an infant the gift of speech to defend its mother against the charge of adultery.

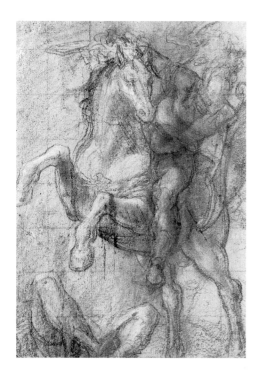

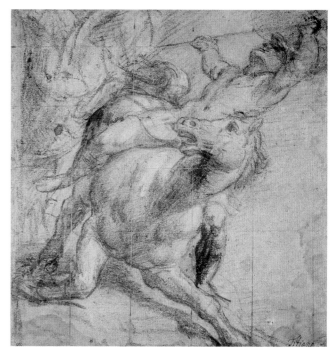

left
Battle on Horseback, 1573/38

right
Rider falling off a Horse, *c.* 1537

Study for Saint Peter, *c.* 1516

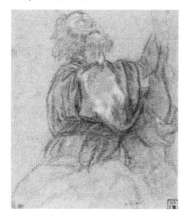

Pordenone, Titian was finally spurred into action. In 1538, with his creation of boldly foreshortened figures, he succeeded in beating his rival at his own game – largely derived from the work of Michelangelo.

As the First Painter of Venice, the title he had inherited from Bellini, Titian went on to produce masterpiece after masterpiece, not only for the city he had chosen as his home. But it was in Venice that he continued to conduct his most progressive experiments in the genre of the altarpiece.

Titian's earliest altarpiece, *St Mark Enthroned with Saints* (*opposite page*), enlivens the conventional format of a Sacra Conversazione by its use of asymmetrical composition. Saint Cosmo in the left-hand foreground turns into the pictorial space to look at Saint Mark. Saint Damian beside him gestures towards Saint Roch and Saint Sebastian on the right. These patron saints of the plague victims are appealing to the patron saint of Venice for his protection, probably on the occasion of the epidemic of 1510, the effects of which were to leave lasting traces in the city.

A few years later, a huge altarpiece by Titian was to cause a sensation. With a height of almost seven metres, the *Assumption* in the Frari Church is not only the largest altarpiece ever created in Venice, but also a key work in Venetian history painting (see p. 46). This is the work that the Renaissance man of letters Lodovico Dolce identified as mark-

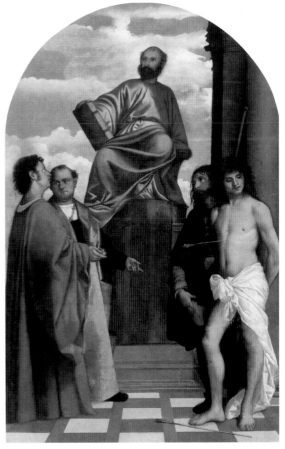

Saint Mark Enthroned with Saints Cosmas and Damian, Rochus and Sebastian (Mark Altar), *c.* 1508/09

In 1565, on the dissolution of the Augustinian monastery of Santo Spirito in Venice, many works, including this St Mark altarpiece by Titian, were transferred to the church of Santa Maria della Salute. Today, the altarpiece can be seen in the church sacristy. It marks the beginnings of a revolution, not only within Titian's own œuvre, but in the painting of altarpieces in general, that was to culminate in the *Madonna with Saints and Members of the Pesaro Family* (see p. 49).

ing the beginning of the Venetian *nuova maniera* that was to replace the 'cold and lifeless figures' of earlier times. The unveiling of the altarpiece in 1518 made Titian truly famous.

For the Franciscans who had commissioned the *Assumption* in 1516, the image above the high altar was intended as a triumphal confirmation of the theologically contentious doctrine of the bodily Assumption of Mary. This particular iconographic type had previously been formulated by Andrea Mantegna in his 1456 fresco in the Ovetari Chapel of the Eremitani Church in Padua, which Titian almost certainly knew. But what a transformation it has undergone here. Never before had such enormous figures been seen in a Venetian altarpiece. The apostles grouped around the sarcophagus of the Virgin are gesticulating with pathos and astonishment. The characterisation of the individual figures is richly orchestrated (redolent of Leonardo da Vinci's *Last Supper* in Milan) as they watch Mary rising heavenwards on a bank of clouds, hands outstretched in a gesture of devotion and humility, to join the figure of God the Father who leans towards her before the golden aureola of a choir of angels. The metaphysical subject matter becomes a *historia*, the visualisation of an act that rhetorically invites the spectator to identify with the events portrayed. The *sanctuarium* of the Frari Church is one of the few authentically preserved complexes of

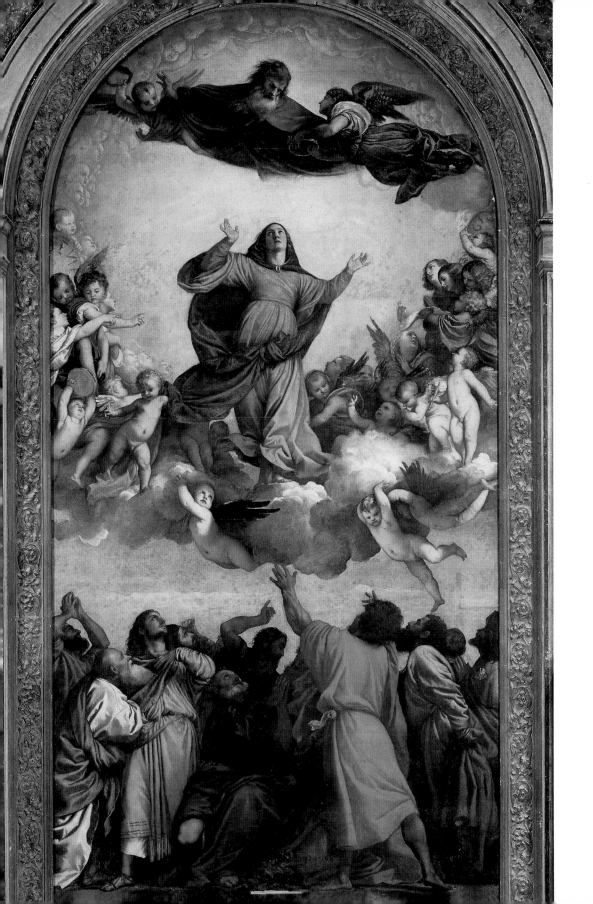

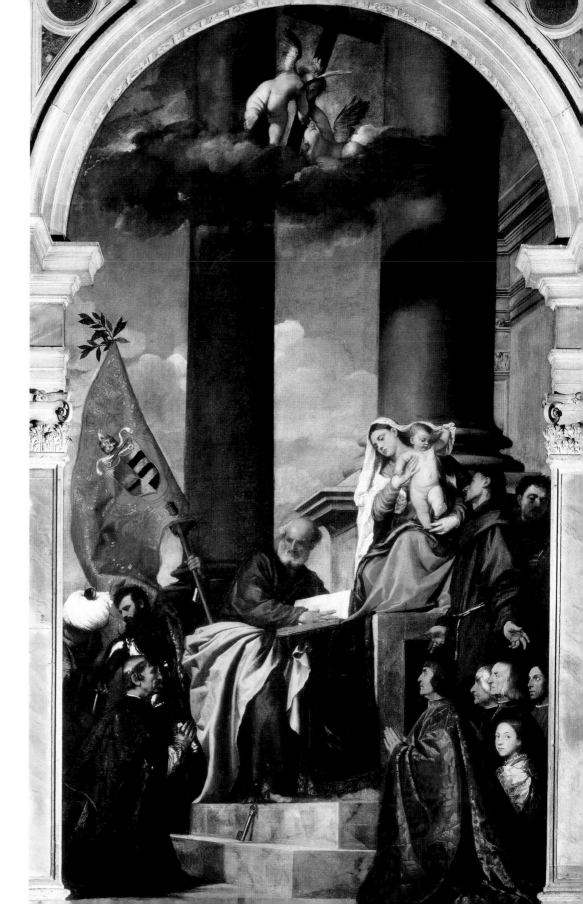

Théodore Géricault, **The Martyrdom of Saint Peter** (after Titian), *c.* 1814, oil on panel, Öffentliche Kunstsammlung, Basle

When Titian's altarpiece of the martyrdom of St Peter was unveiled in April 1530, it was hailed by his contemporaries as marking the dawn of a new age of painting in Venice. This was the only work by Titian to receive unmitigated praise from Visari. Destroyed by fire in 1867, it was reproduced and copied countless times over the centuries. One of the most compelling interpretations of this work is by the French Romantic artist Théodore Géricault.

Page 46
Assumption of the Virgin, 1516–18

Page 47
Madonna with Saints and Members of the Pesaro Family, 1519–26

any Italian monastic church. It is not only the dimensions of the *Assumption* that lend this space a note of overwhelming power. It is also the handling of colour, the composition and the unique visual orchestration of energetic movement that make Titian's monumental painting such a focal point. Even when viewed from the layman's pews, through the rood screen, it is as potently evocative from a distance as it is close to.

Titian's talent must have astounded the art connoisseurs of his day. The monks, however, were somewhat bemused by the boldness of his composition and by the use of colour, in which the typical 'Titian red' must have seemed all too sensual. However, when an imperial envoy sought to purchase the painting and have it shipped to Vienna, they immediately took note – and kept the altarpiece.

In order to study Titian's next stroke of genius in the field of religious art, we need not even leave the Frari Church. His *Madonna with Saints and Members of the Pesaro Family* (see p. 47) graces the altar in the forth bay of the left-hand aisle of S. Maria Gloriosa dei Frari. It was donated in 1518 by the Venetian noblemen Jacopo da Pesaro, Bishop of Paphos (Cyprus) and his brothers, who are portrayed in the painting. The painting, which shows a young Turkish prisoner and a young Moor, was intended to commemorate the victory (called into question by some contemporaries) by the bishop over the Turks in 1502 at Sta Maura (Levkas) as commander of the papal fleet. It was also meant to fuel support for a new crusade. None but Titian could have been considered for such an ambitious project. He began work on it one year later and received his final payment in 1526.

Saints Peter, Francis and Anthony stand on the steps leading up to the throne of the Virgin Mary. Titian does not portray the object of devotion – the Virigin and Child – frontally in the centre of the composition, but shifts them – revolutionising the genre of altar painting and setting in motion something that was to be adopted as commonplace in the baroque: a scene running into the depths of the pictorial space along a diagonal.

In 1528, Titian began work on a painting for the Altar of the Brotherhood of Saint Peter the Martyr for the Church of SS. Giovanni e Paolo. This was probably preceded by a competition that Titian won against his older Venetian colleague Palma il Vecchio and his rival Pordenone. The resulting painting, unveiled in April 1530, is lauded by Dolce, along with the Assumption, as an incunabulum of 'new painting' in Venice. Even Vasari enthused. Such detail, such reduction to a few monumental figures, such breathtaking counterpoint of setting and event, were unprecedented. In 1867 a fire destroyed what was surely the most talked-about example of Venetian painting.

In comparison with such epochal milestones as the *Assumption*, the *Pesaro Altarpiece* and the *Saint Peter Martyr*, the *Presentation of the Virgin* (*opposite page*) painted in 1534–38 is a more modest achievement. It may not have been possible to complete in any other form, given the extreme landscape format dictated by the original situation, which permitted only relatively small figures. Titian's patrons at the Scuola Grande della

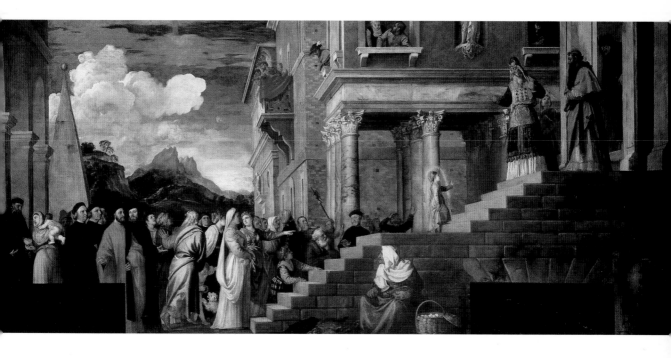

above
Presentation of the Virgin at the Temple,
1534–38

This monumental painting is one of the
few major works by Titian that still remains
in the place for which it was originally
intended. In the course of time, however,
it has undergone considerable changes.

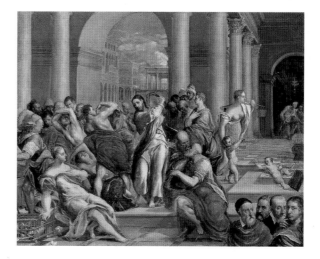

right
El Greco, **The Purification of the Temple**,
1570–75, oil on panel, 118 x 150 cm, The
Minneapolis Institute of Arts, Minneapolis

El Greco was a pupil of Titian. His *Purifica-
tion of the Temple*, now in Minneapolis,
integrates four portraits into the biblical
theme at the lower right hand edge, includ-
ing what is probably a self-portrait and a
portrait of his teacher. It is possible that
this also contains a reference to a painting
of the same subject matter, created shortly
before, in which Jacopo Bassano is said to
have included the figure of Titian among
the money-changers as a jibe at his alleged
love of money.

Triumph of Faith, *c.* 1511

Carità do not seem to have been overly impressed by the result, for they negotiated with Titian's arch-rival Pordenone when it came to commissioning a painting for the adjacent wall.

By 1513 at the latest, Titian was running a workshop with as many as ten assistants, among them his own son Orazio and his nephew Cesare. In a letter to King Philip II dated December 1567 Titian mentions 'a very talented young pupil of mine'. The reference is probably to El Greco (*opposite page*). At any rate, this artist was presented soon afterwards to Cardinal Alessandro Farnese in Rome as an apprentice of the great Venetian artist. Woodcutters, too, among them the famous Ugo da Carpi, frequented Titian's studio.

Venice was one of the world's most important centres of printing. Titian, as one of the first of Italy's great painters to take a keen interest in woodcuts, channelled this art form into bold new directions, taking much of his inspiration from Dürer. Titian's landscape woodcuts, in particular, enjoyed enormous popularity and were to become benchmarks for Bolognese landscape art of the sixteenth and seventeenth centuries. Peter Paul Rubens and Anthony van Dyck copied Titian's woodcuts. A drawing based on a woodcut by Titian even emerged in the circle of Rembrandt.

Titian's house and studio in the Biri Grande district, now the Fondamenta Nuove in the north of Venice, was a place of lively social interaction. A letter penned by the Florentine scholar Francesco Priscianese, mentions a dinner there in August 1540. It describes the beauty of the garden, the sight of gondolas plying the northern lagoon and the views of the island of Murano. In his beautifully situated but by no means feudal domicile, Titian corresponded prolifically, though there is little mention in his letters of his paintings. This, however, is by no means an indication that the artist was not interested in theoretical discourse.

In Priscianese's letter there is mention of members of the Accademia Pellegrina attending the dinner. The Accademia Pellegrina was a circle of humanist intellectuals that included Titian's friends Jacopo and Francesco Sansovino as well as Lodovico Dolce, one of the most ardent admirers of Titian's art.

Titian's erudition is indicated still more clearly by an incident in Venetian architectural history. On 15 August 1534, Doge Andrea Gritti laid the foundation stone for the Church of S. Francesco della Vigna. During the planning stage, the Doge had obtained a survey of the proportions from the cleric Francesco Giorgi. He had based his proposals on the Pythagorean-Platonic philosophy of harmonious numbers. One year later, three others were to pass judgment on this paper: Fortunio Spira, a leading humanist of the day, the star architect Sebastiano Serlio – and none other than Titian.

Titian was a magician of colour, a virtuoso of light, an opulent sensualist; the counter-image of him as a profound thinker and Neo-platonic philosopher was outlined decades

ago by the art historian Erwin Panofsky. One of the most important examples cited by Panofsky in formulating this view of Titian was his painting of *Sacred and Profane Love* (see pp. 52/53), undoubtedly one of the loveliest and most balanced works by the Venetian master. According to Panofsky, the naked figure represented the 'Venere Celeste' and embodied the principle of universal and eternal beauty, intelligible only to the mind, while the clothed figure was the 'Venere Volgare', the visible and tangible image of beauty on earth. Amor, stirring the waters in the fountain between the earthly and celestial figures of Venus, symbolised the Neo-platonic notion of love as a principle of cosmic 'mixing'. Even if current scholars have questioned this supposed Neo-platonic undercurrent, it by no means detracts from the intellectual profundity of this superb painting which is now regarded primarily in its function as a wedding picture.

The painting was created to mark the marriage of Niccolò Aurelio and Laura Bagarotti. This has been deduced, though not without controversy, from the escutcheon of the bridegroom on the sarcophagus that forms the trough of the fountain. Niccolò was the secretary of the Venetian Council of Ten. His bride came from a Paduan family that had rebelled against Venice, for which some of Laura's relatives had been executed. It was thus a marriage that was bound to rankle, and the Signoria accordingly set about trying to prevent it. The white dress of *Profane Love* allegedly represents Laura's wedding dress, which was confiscated by the Venetian authorities and handed over only shortly before the marriage in 1514. Restoration findings indicate that Titian had taken this incident into account by over-painting the original red dress with a white one. The relationship between the bride and groom, endangered from the start if the historic statements are correct, was thus seen to be vindicated in the sublimation of love portrayed by Titian.

Paolo Giovio, writing in 1523, claimed: "The paintings of the Venetian artist Titian radiate such erudition that they can be understood only by artists, though not by plebeian ones." Nowhere is such 'intellectual art' as clearly manifest as it is where Titian celebrates a *paragone*.

The term *paragone* is used to describe the competition between painting, sculpture, poetry and music. The Florentine historian Benedetto Varchi, who, during his Venetian exile in 1536–40, made friends with *Pricianese* and very probably with Titian as well (see p. 54), made the long-debated notion of the *paragone* a firm component of Italian literature. While sculptors sought to discredit the illusory powers of painting as mere deception, painters proffered it as a strength.

The fact that Titian himself took a stance on the *paragone* debate in his paintings is evident in his early portrait of *La Schiavona* completed around 1510 (see p. 55). By introducing a trompe l'œil marble balustrade that echoes the frontal portrait of the sitter in *relievo* profile, Titian extended the portrait to become a *paragone* piece. He seems to be saying that painting is just as capable as three-dimensional sculpture of presenting

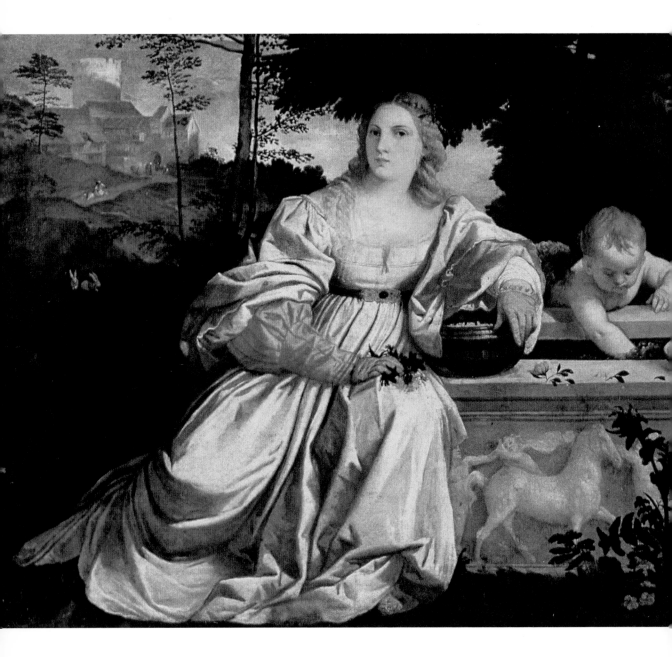

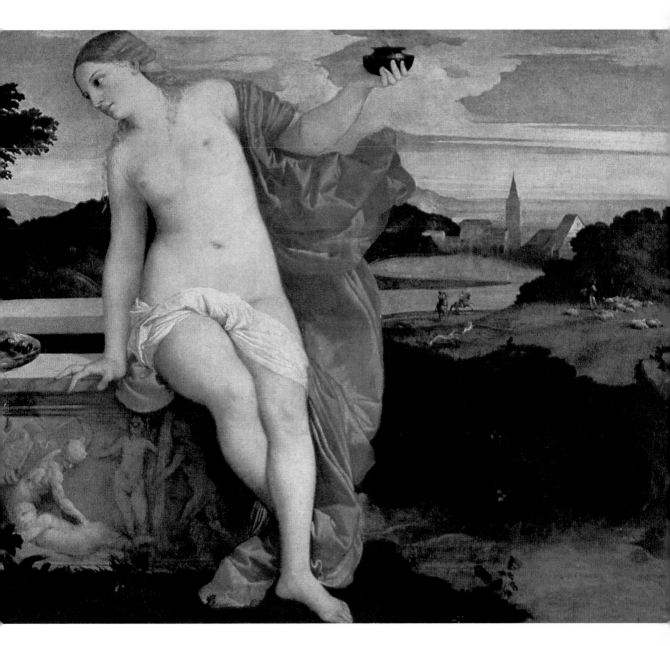

Sacred and Profane Love, 1515/16

This painting, widely regarded as one of the finest Titian ever created, may well have been produced to document a politically controversial marriage. The bride is from a Paduan family that had been involved in an uprising against Venice. The white garb of 'profane love' – painted over what had originally been a red robe – probably represents the bridal gown of Laura Bagarotti that was confiscated by the Venetian state and returned to the young woman by a council official shortly before the wedding in 1514.

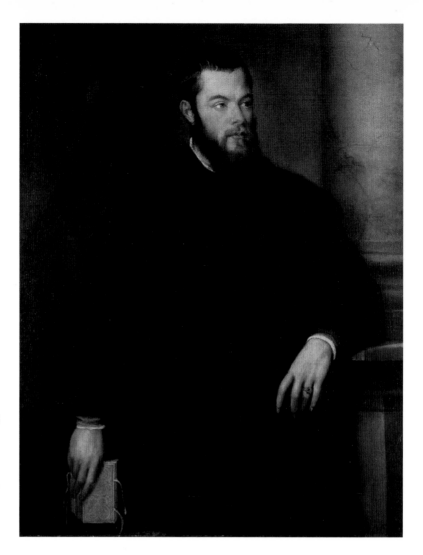

Portrait of Benedetto Varchi, 1540–43

This dignified figure was one of the leading scholars and art connoisseurs of his day. He left his native Florence to escape the tensions triggered by the Medici return to power and lived in exile for fifteen years, some of them in Venice. Titian presents his friend with an aura of quiet refinement and self-assured noblesse. At the same time, Varchi's pensively contemplative expression lends him an air of great intellectual cultivation.

several different views of a figure. Moreover, the colours in this painting evoke a tactile quality that is strikingly demonstrated in the superbly imitated marbling of the stone.

Titian was fighting other battles too, and no less intellectual ones at that, wherever he encountered the latest artistic trends. Since the regulations of the guilds were virtually ignored, the art world saw fit to seek another code of honour. In 1548, Paolo Pino demanded that all artists should be appropriately dressed, groomed and perfumed, that they should be well educated, discreet in their business dealings and refrain from sexual promiscuity. However, he also maintained that if a rival should encroach on an artist's territory, he should be challenged to a duel, or competition. By way of example, Pino cited Titian's victory over Palma il Vecchio in winning the commission to paint *Saint Peter Martyr*. Titian himself would go on to fight many another duel – starting with Giorgione and the Old Master Bellini. Titian must have possessed enormous self-assurance and an ability to put his case persuasively to the nobility in order to pose a serious challenge to Bellini as official painter to the state – let alone in order to appropriate and

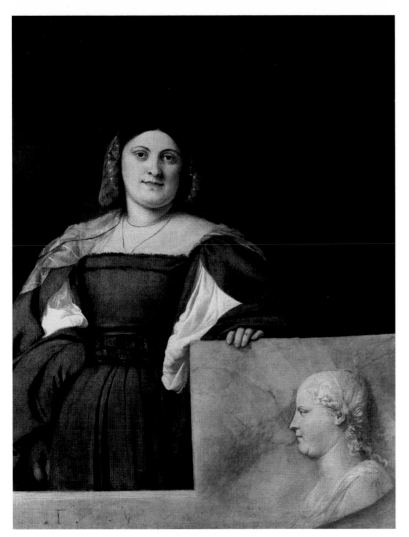

La Schiavona, *c.*1510

This early portrait of a woman whose facial traits are echoed in the *relievo* bust on the marble parapet, but whose identity has not been fully ascertained, clearly indicates that Titian was perfectly familiar with the notion of the *paragone*, as the age-old rivalry between painting and sculpture is termed. Titian proves that even a painter can portray a figure from different angles at the same time and that, unlike a sculptor, a painter also has the ability to conjure up the qualities of colour and texture. Titian shows this in the graining and marbling of the stone – the very material of the sculptor – which he so perfectly imitates.

repaint Bellini's *Feast of the Gods* (see p. 61) after the latter's death in 1516 before integrating it into his own cycle of three bacchanalian scenes in Ferrara.

At that time, in 1522, Titian also completed the polyptych with Christ Risen on its central panel, Saint Nazarius and Saint Celsus with the donor on the left-hand panel and the right-hand panel showing Saint Sebastian with Saint Roch in the background and above them the Angel of the Annunciation and the Virgin Mary. This retable graced the high altar of the Church of SS. Nazaro e Celso in Brescia (see p. 57).

The most famous figure in this work is that of Saint Sebastian, which bears the artist's signature. Titian himself claimed that it was the finest painting he had executed up until then. The Duke of Ferrara did all he could to acquire the panel, but in vain. However, he did receive a replica by the artist. The artistic brilliance of this Saint Sebastian lies in the torsion of the body, which paraphrases aspects of Michelangelo's *Slaves* and the central figure in his *Laocoon*. Here we find an already established painter competing with world-famous works of sculpture and with the ubiquitous hero of the High Renaissance.

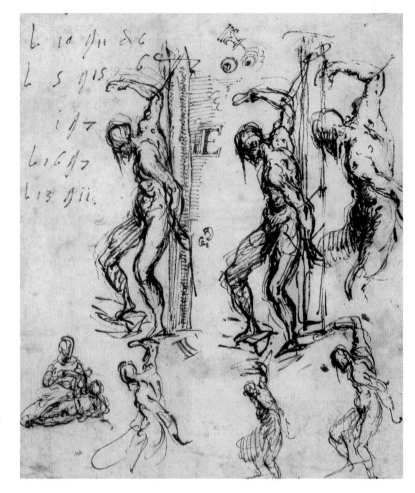

Six studies for Saint Sebastian and a Virgin and Child, *c.*1520

The survival of two preliminary sketches for a monumental painting (the Averoldi polyptych on the following page) – this one in Berlin as well as a pen and ink drawing in the Staedel in Frankfurt – is highly unusual in Titian's œuvre. Both studies bear witness to his consummate draughtsmanship.

Titian's most dangerous rival, in every respect, however, was Pordenone. Titian had encountered him at the latest by 1520, when he painted the *Annunciation* (see p. 123) for the Malchiostro Chapel in the Cathedral of Treviso, where Pordenone executed the wall and cupola frescos. The figure of God the Father almost explodes the bounds of the cupola with a swirling dynamism the like of which Venetian painting had never seen before – almost a painted critique of Titian's *Assumption*. This triggered a *paragone* that focused on complex perspective and bold foreshortening – weapons that, once again, were drawn from the arsenal of Michelangelo's œuvre. Even after the death of his rival, Titian sought to outdo him in his ceiling paintings for the monastery church of S. Spirito (see pp. 58, 59), which are almost exaggeratedly acrobatic.

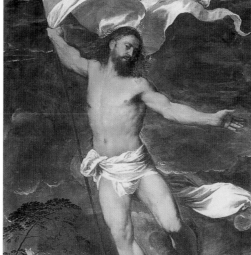

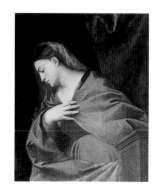

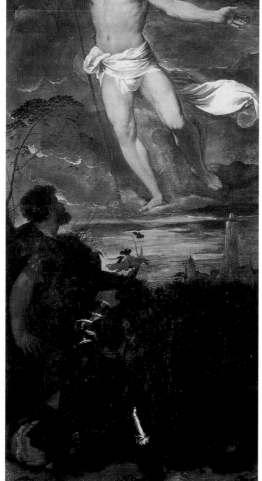

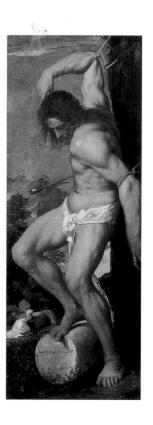

**The Reserection in Brescia (Averoldi –
Polypthych),** completed 1522

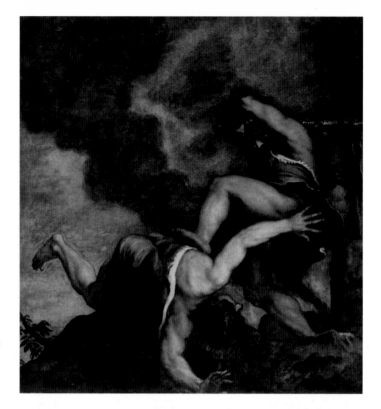

Cain and Abel, 1544

It was in the 1540s, when Titian had to
contend with the *terribilità* of Pordenone,
a keen admirer of Michelangelo, that he
created these ceiling paintings for the
church of Santo Spirito in Isola, most of
which were later transferred to the Basilica
of Santa Maria della Salute. Stylistiscally
they are influenced by Vasari, Giulio
Romano, Correggio and Michelangelo.
In response to Pordenone's exaggerated
body forms and violent contortions, they
represent an idiom that has been described
as the Mannerist phase of Titian's œuvre.
The compositional overdrive is perfectly
in tune with the gruesome nature of the
biblical themes.

right
The Sacrifice of Isaac, 1544

Page 59
David and Goliath, completed in 1544

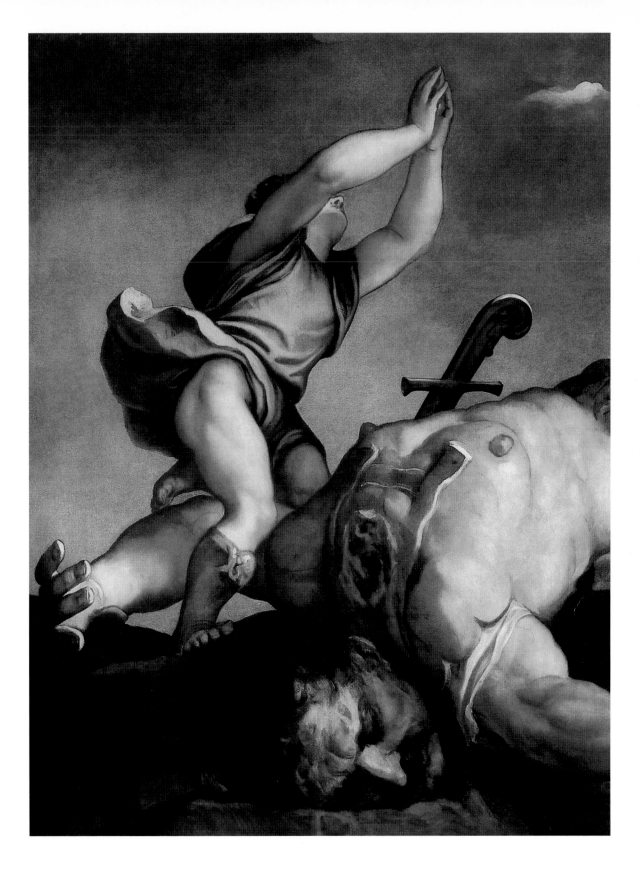

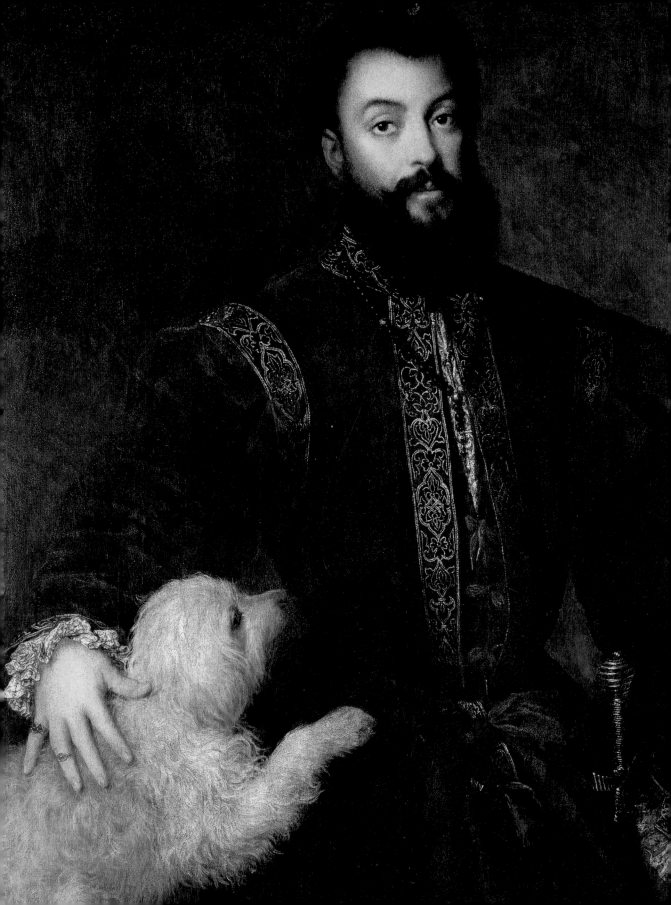

Noblesse Oblige

"There is hardly a nobleman, a prince nor any lady of rank whose portrait has not been painted by Titian, truly a most supreme master of this form of art."

Giorgio Vasari in 1568 about Titian's portraiture

Estimates of the number of paintings created by Titian in the course of his long life vary between about 400 and 600. It is difficult to determine the true figure because of the existence of countless variations on certain compositions, especially those that were destined for princely collections, such as the nudes so often requested by aristocratic patrons. For instance, Titian's studio produced more than thirty painted or etched versions of the enormously successful *Venus and Adonis* (see p. 97). Some religious subjects, too, proved highly popular, among them various more or less lascivious portrayals of *Saint Mary Magdalene* (see pp. 100, 101). If these works are taken into account, his œuvre swells easily to some 600 works. This means that Titian's output averaged eight paintings a year, aimed predominantly at a clientele that was, of course, not limited to Venice itself.

Starting with Alfonso d'Este in 1516, Titian won patrons at the courts of Northern Italy and then throughout Europe, who eagerly acquired his works. Only the Medici in Florence remained aloof. From 31 January to 22 March 1516 Titian visited Ferrara to discuss a cycle of mythologies for Alfonso d'Este's *studiolo* in the Palazzo Ducale (also known as the Camerino d'Alabastro, or Alabaster Room). It is no longer possible to reconstruct either the room or the decoration. At any rate, the new works were meant to be grouped around Giovanni Bellini's *Feast of the Gods* – a moral sermon juxtaposing chaste nymphs and lascivious, drunken gods in a manner reminiscent, perhaps with specific iconographic intent, of an ancient costume piece. Much later, in 1529, at the request of the duke, Titian spiced up the painting, revealing the breasts of the female revellers, placing Neptune's hand in Cybele's lap and adding various attributes. Above all, however, he made the landscape more dramatic. There is no record of any

Frederico Gonzaga with a Dog, 1529

This portrait was not painted on canvas, but on panel. Its modernity lies in such features as the little white dog – the lapdog traditionally being a symbol of marital fidelity. Federico intended this detail to counter the reputation he held as something of a philanderer – his passion for Isabella Boschetti was well known – and provide a suitable portrait for a future wife.

Giovanni Bellini and Titian, **Feast of the Gods**, 1514

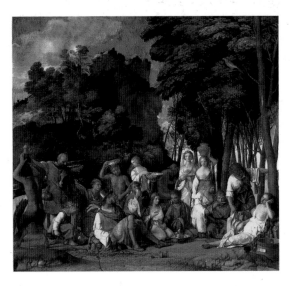

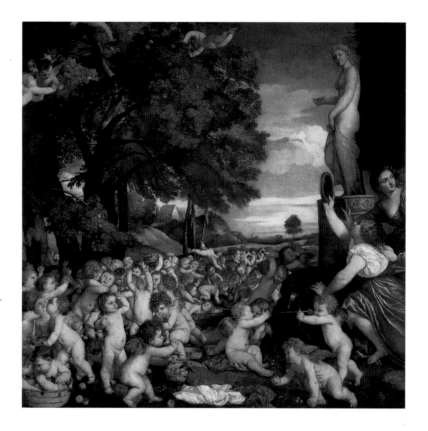

Worship of Venus, 1519

In the spring of 1518 Alfonso d'Este commissioned Titian to paint the *Worship of Venus,* which was completed one year later. A letter from the artist dated 1 April 1518 confirms that Alfonso provided him not only with the necessary materials but also with precise instructions as to the content of the picture. A letter to Alfonso from Jacopo Tebaldi, envoy of the court of Ferrara to Venice, also tells us that Titian had received a relevant sketch – probably a design by his fellow artist Fra Bartolommeo who had originally been meant to paint this subject, but who had since died. Titian adopted several details from the sketch.

personal statement that might indicate how Titian actually felt about reworking the wonderful painting of his former mentor and rival. Did he feel trepidation or triumph? As in the later self-portrait Titian gives nothing away that could allow posterity to make any individual psychological interpretation. His artistic genius, however, is displayed for all to see – Titian the master, in the service of a progressive patron,embodies the new mindset that has superseded Bellini's composition.

By reworking Bellini's painting, Titian was also able to make it fit in more easily with his own compositions and inventions.

In the spring of 1518, he started work on the *Worship of Venus* (*above*) – his first foray into the realms of ancient mythology, albeit with specific iconographic instructions from Alfonso d'Este. Initially, it was Raphael who had been envisaged for this project, but he died in 1520, leaving Titian with the task of painting a *Bacchus and Ariadne* (*opposite page*) based on the tradition of the classical triumphal procession. The central figure of Bacchus is a compositionally somewhat unsatisfactory quote of a classical Orestes sarcophagus (Museo Lateranense Profano, Vatican).

Bacchus and Ariadne, *c.* 1520–23

Titian's *The Andrians* (*Bacchanalia*) (*opposite page*) was created immediately afterwards. It shows the inhabitants of the Greek island of Andros indulging in an orgiastic festival of wine while awaiting the arrival of Bacchus, who has made their soil fertile and provided an abundance of grape-laden vines. Whereas Bellini's original painting had portrayed wine and sexual desire as the enemies of virtue, Titian celebrates them: "Who drinks and does not drink again, does not know what drinking is," proclaims the sheet music of a French song near the front of the picture (French music was considered the most progressive at the court of Ferrara). Moreover, where Bellini had portrayed a slumbering nymph whose chastity is at risk, Titian famously shows a bacchante in a state of complete undress, sleeping off her drunken stupor. Life lived so close to nature is portrayed here in a manner that is no longer subject to moral judgment, but is celebrated instead – like the exuberant figure of Bacchus in the adjacent picture – as part of a Dionysian culture of human passions savoured to the full in a golden age.

The Marquis of Mantua, the nephew of Alfonso d'Este, who now became Titian's patron, is likely to have been familiar with a few of these vivid and sensually titillating myths. Their initial contact is documented in a letter dated 26 December 1522 in which Federico requests Malatesta, his envoy to Venice, to invite Titian to spend the feast days in Mantua. Titian, however, had quite enough to do for the court of Ferrara at the time. Nevertheless, as soon as he had completed his mythology cycle in 1529, he began working for the generous Federico rather than the curmudgeonly Alfonso. This new patronage was to result in one of sixteenth century Italy's finest portraits: *Federico Gonzaga with a Dog* (see p. 60). Portraits of Federico's sister Eleonora Gonzaga (see p. 93) and her husband Francesco Maria della Rovere (see p. 129) as well as at least two portraits of Federico and Eleonora's mother Isabella d'Este (see p. 125) followed. In the years to come, Titian produced more than thirty paintings for the court of Mantua.

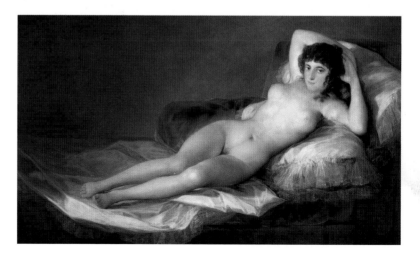

Francisco de Goya, **The Naked Maya**,
c. 1798–1805, oil on canvas, 95 x 190 cm,
Museo del Prado, Madrid

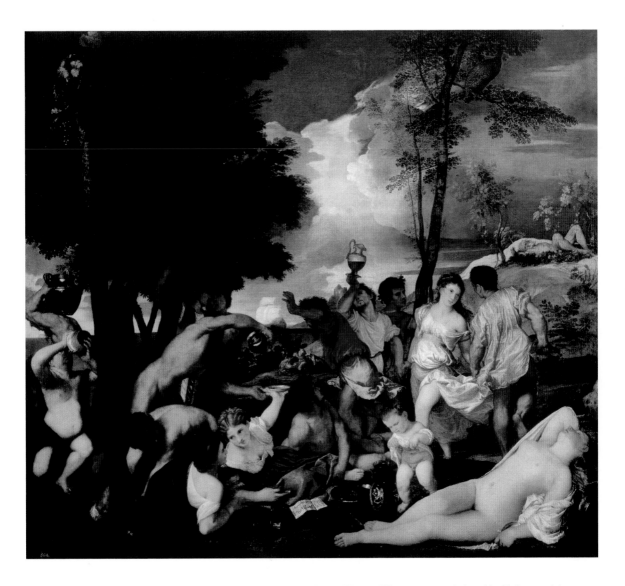

The Andrians (Bacchanalia), 1523

It is possible that Alfonso d'Este and his sister Isabella d'Este visited Titian in 1523. The Marchese had fled from an outbreak of plague in Ferrara. While in Venice, he may well have inspected the progress of *The Andrians* (*Bacchanalia*) that he had commissioned for his famous alabaster room in February of that year.

The lascivious nude on the lower right sleeping off her drunken stupor inspired Goya to paint his *Naked Maya*.

King Philip II, 1550/51

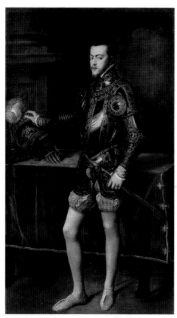

above right
Johann Friedrich of Saxony, 1550/51

To mark his victory over the Protestant troops in 1547, Emperor Charles V commissioned Titian to paint not only a portrait of him and his entourage, but also of his main opponent, Johann Friedrich, the Elector of Saxony. Now at the height of his prowess as a portraitist, Titian has captured the thick-set body and distrustful dignity of the defeated Protestant leader whose figure seems to fill the composition with a direct presence and a timeless monumentality.

Unfortunately, one of the most important of his Mantua projects now survives only in the form of copies, drawings and engravings after the original paintings done by Titian from 1536 onwards for the Camerino de'Cesare, designed by Raphael's pupil Giulio Romano, in the Palazzo Ducale. It is a cycle of eleven portraits of Ancient Roman emperors. This iconic 'catalogue' of great men, completed in early 1540, was to have a lasting impact on portraiture for many years to come. In 1628, the imperial portraits were sold to King Charles I of England and restored in London by Anthony van Dyck. In September 1652 they were transferred to Madrid, where they were destroyed by the great fire in the Alcázar in 1734.

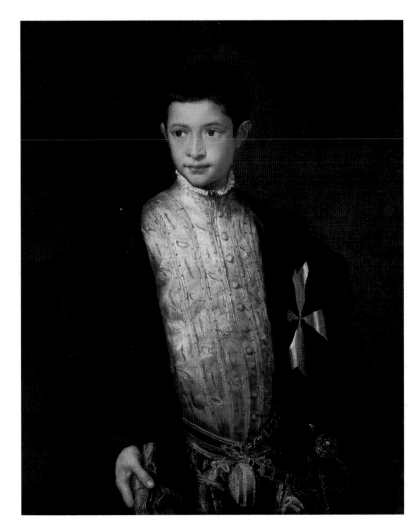

Portrait of Ranuccio Farnese, 1541/42

The Farnese family was eager to obtain the services of an artist whose international standing made him a sought-after portraitist of the rich and powerful. Titian was commissioned to paint a portrait of Ranuccio Farnese, the grandson of Pope Paul III, who was just twelve years old.

It was Federico Gonzaga who first introduced Titian to Emperor Charles V. Their acquaintance was one of great mutual respect and even developed into something that might be described as friendship. Certainly, it was one of the most fruitful relationships ever to be forged between patron and painter in the entire history of art. On 10 October 1529, the Marquis called Titian to come to Mantua as soon as possible to paint a portrait of Charles.

By mid-January 1533, Titian had completed the first (no longer extant) portrait of Charles V. For this work he received the princely sum of 500 ducats. On 10 May 1533, the Emperor made Titian a nobleman, creating him a Count of the Lateran Palace, of

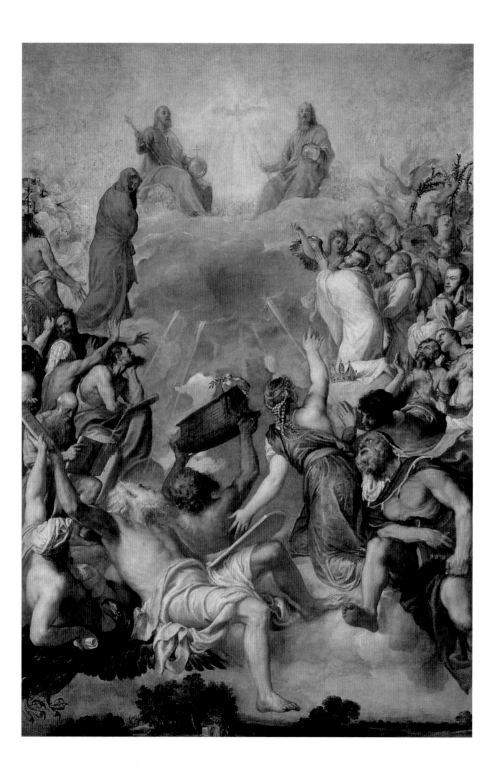

the Aulic Council and the Consistory, and giving him the title of Count Palatine. From that time onwards, Titian's children were nobles of the imperial realm with all rights and privileges appertaining to families of four generations. In addition to these honours, Titian was also made a Knight of the Golden Spur.

A good decade later, in 1547, Titian was summoned to the Imperial Diet at Augsburg, which the Emperor had called following his victory over the Prince Elector of Saxony at the Battle of Mühlberg (see p. 66). The fact that the Venetian artist had constant access to the Emperor was documented by the reformist Philip Melanchthon in a letter to his friend Camerarius. Charles referred to Titian as the 'new Apelles', setting him on a par with the most celebrated painter of classical antiquity. The two were to meet several more times before the Emperor abdicated in 1556 and retired to the monastery of San Gerónimo de Yuste in Spain, handing on the patronage to his son Philip II (see p. 66).

In the meantime, the Farnese family in Rome had also discovered the talents of Titian. Cardinal Alessandro, in particular, was eager to have such an outstanding artist in the service of the family. Accordingly, he commissioned a portrait of his younger brother Ranuccio Farnese (see p. 67). This twelve-year-old lad had been sent to study at Padua in 1542, which meant that Titian could paint him without having to travel too far from his home town. The finished result exceeded all expectations.

Shortly afterwards, the Farnese Pope Paul III summoned Titian to Rome, tempting him with a benefice for his son Pomponio and with the lucrative post of *piombatore* (Keeper of the Papal Seals) for the artist himself. Titian declined the office, for it would have meant ousting his colleague, the Giorgione pupil Sebastiano Luciani (better known as Sebastiano del Piombo). Still, flattery and promises eventually had the desired effect. In September 1544, the papal nuntio in Venice, Giovanni della Casa, wrote to report that the artist had declared his willingness to paint all the Farnese family, 'even their cats and the courtesans of the cardinals' – provided the benefice was made available. And so it was that in October 1545 Titian set out for Rome in the company of his second son Orazio. The journey there was nothing short of a triumphal procession. Once he arrived, Titian resided in the Belvedere. Vasari, returning from Naples, acted as his guide and showed him the 'great ancient stones' of which Titian wrote to his patron Charles V.

In little more than eight months, Titian painted several religious works as well as some of the most famous portraits in the history of western art, capturing the characters of his sitters with enormous sensitivity. The question as to whether he ever received a fee for this work is one that Vasari forcefully denies in his first edition of the *Lives of the Artists*, only to affirm it equally forcefully in the second edition. What is certain, however, is that the generous benefice never materialised, though the Pope did confer the citizenship of Rome on Titian in March 1546 in a lavish ceremony on the Capitol. Laden with marble sculptures and furnished with all the necessary papal travel permits, Titian embarked on his return journey to Venice in mid-June 1546.

Gloria, *c.* 1551–54

In 1548 Emperor Charles V summoned Titian to the Reichstag in Augsburg to paint his portrait as the victor over the Protestant forces. When the artist returned again to Augsburg two years later, Charles, already considering abdication, commissioned two more paintings: a portrait of his son Philip II in armour (see p. 66) and a large religious painting that included the figure of the Emperor himself garbed in a shroud and worshipping the Holy Trinity. For many years, this key painting of the Counter-Reformation hung above the high altar in the church of the San Yuste Monastery, where the former emperor could see it from his bedchamber. In the painting, Charles has already set aside the trappings of worldly power: crown, sceptre and robes. This is a highly unusual portrayal of Catholic Christendom's most powerful ruler set within the context of a Last Judgment.

The magnificent painting *La Gloria* (see p. 68) was commissioned by Charles V in 1550 and taken to Spain by him on his abdication. It was placed on the high altar at the monastery of Yuste, where Charles could see it from his bedchamber. In the painting, the patron, surrounded by family members, kneels before the throne of the Holy Trinity, wearing the robes of penitence, having set aside the insignia of worldly power. Titian has placed just three New Testament figures, including Mary Magdalene, in the heavens – but otherwise the tableau is far from conventional, being a highly personal interpretation of the Last Judgment in which only the patriarchs and prophets of the Old Testament play a role.

It was not only this eschatological *memento mori* and other religious compositions that Titian produced for the rich and powerful of the day, but also allegories and mythologies. Above all, however, it was his reputation as a portraitist that made him the toast of the European courts. Titian's life work includes more than eighty male portraits. By contrast, he painted only thirteen female portraits, most of them allegorical studies of a more or less erotic character. There is also a handful of quite remarkable children's portraits. Clarissa Strozzi, for instance, was just two years old when she sat for Titian in Venetian exile (*opposite page*). The little girl appears grown-up and important because the artist has taken her seriously. In fact, he has taken her seriously as a child, who, though she is clearly striking a pose, is not endowed with any insignia of rank or power, but is holding what appears to be a pretzel.

Titian's success as the most sought-after portraitist of the European aristocracy went hand in hand with the rise of portraiture as a genre. His paintings were to set the benchmark for all portraiture right through to the eighteenth century, firmly establishing the grand pose, the contrasting movement of head and body, the hand placed on the hip, grasping a military baton or reaching for the pommel of a dagger. This did not mean that the pose itself in any way diminished the individuality of the sitter, however, for Titian imbued his portraits with a depth of expression and universality of meaning, presenting a notion of the ideal that was no longer the sole preserve of religious or history paintings.

One outstanding example of Titian's portraiture is dedicated to his friend, the writer Pietro Aretino, the son of a cobbler from Arezzo (see p. 73). Until recently, it was thought that Titian and Aretino first met in Venice in 1527. However, two documents dated 3 February 1523 indicate that they had already met at the court of the Gonzaga. Vasari says of their friendship that "it proved of great advantage to Titian, in spreading his name as far as Pietro's pen reached, especially to notable princes …"

Aretino became the first journalist of European stature, feared as the *flagello dei principe* (scourge of princes) by those in power, who sought to curry favour at all costs in the hope of staving off his infamously venomous attacks. With Aretino, the power of the press and the leverage of slander arrived on the scene. In the course of his life, he

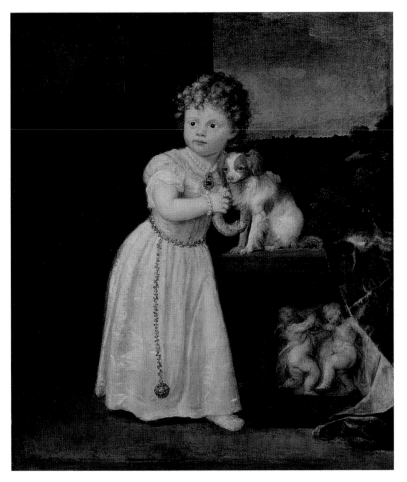

Portrait of Clarissa Strozzi, 1542

The two-year-old girl is leaning against a stone table, the base of which has a marble relief in classical style with dancing putti. The little girl is feeding a pretzel to her lap-dog. Clarissa was the oldest daughter of Roberto Strozzi and Maddalena de'Medici of Florence. She was born in Venice, where her parents were in exile, and this is where her portrait was painted. In a letter to Titian dated 6 July 1547, Pietro Aretino enthuses to his artist friend about the beauty and natural pose in this work, which is now widely regarded as one of the first autonomous children's portraits in European painting. In 1544 the Strozzi family moved to Rome, taking the portrait with them. In the early nineteenth century, it was transferred to the Palazzo Strozzi in Florence and was acquired in 1878 by the Berlin Museum.

penned some 3,000 or 4,000 letters, 600 hundred of them alone to artists, and published them in six volumes from 1537 onwards. These *Carteggi* were very successful, the first volume being reprinted no fewer than thirteeen times within the space of a few months. In 1552 the author commissioned Alessandro Vittoria to make him a medallion, on the reverse of which he is shown seated on a throne receiving tributes from the kneeling rulers before him. The inscription around the edge bears witness to his ego. It reads: *I Principi tributati da i Popoli tributano il Servator* (The princes having received tribute from the people pay tribute to their servant).

Needless to say, Aretino wanted his portrait painted only by the very best – Titian. Titian painted his friend Aretino at least five times. The portraits are now in Florence and New York. What is more, Titian also included the striking figure of Aretino in other

Ecco Homo, 1543

The iconography of this painting, now in Vienna, is as complex as it is fascinating. It uses the biblical theme of *Ecce homo* as an implicit call for Venice, recently allied with the Emperor, to embark on a crusade against the Turks. The enigmatic and almost translucent figure of the young woman near the middle of the picture – presumably a personification of Venezia heralding a new Golden Age – may be a hidden portrait of Titian's daughter Lavinia.

Portrait of Pietro Aretino, 1545

paintings, such as *Ecce Homo* (see p. 72) now in Vienna, in which he appears as Pilate. In the Florence portrait (*opposite page*), the figure of Aretino fills the canvas. Behind this massive physical presence we can discern something of the writer's arrogance and cynicism as well as the power he wielded through blackmail and scandal. Some modern scholars believe that Titian based his portrayal of Aretino on the physiognomy of Michelangelo's famous sculpture of Moses. Aretino was dismissive, writing of the portrait in terms that equate its artistic quality with money: "Surely I breathe here; the blood circulates, and I see my living self in a painting; had I given the artist a few more crowns he would have bestowed more pains on the material of the dress, the silk, the velvet, and brocade."

In 1545 Aretino gave the portrait to Cosimo de' Medici in Florence. But, whatever the tone of his letter might suggest, he did not do so because he disliked the painting. On the contrary, the gift was intended to persuade Cosimo of the qualities of a painterly style so innovative in its day that some who saw it were quite taken aback. After all, the marks of the brushstroke can be clearly seen close up, while the heavy application of paint on the sleeves of the mantle and the zigzag line on the brown robe beneath it give an impres-

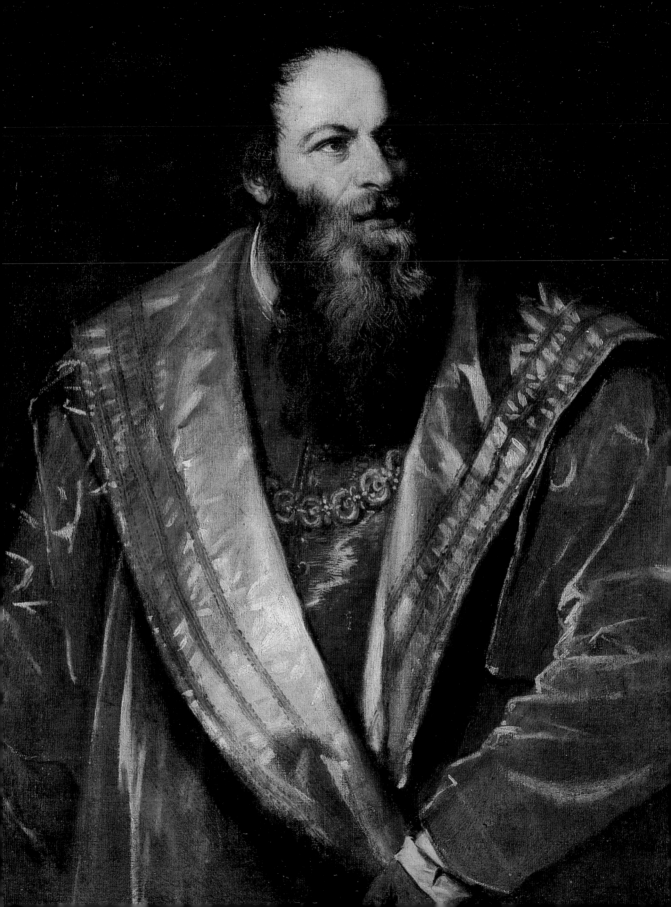

sion of sketchiness and spontaneity that contrasts with the painstaking finish of the glove, the hair and the face. The portrait of Aretino is not the first work by Titian to display such discrepancies in the application of the paint, but is certainly the first to celebrate this technique so ostentatiously.

It is hard to understand how two such different men could have become lifelong friends. Perhaps it was, in part, the mutual admiration of two individuals who had climbed to the very top of their respective professions even if that meant going against the interests of others. Aretino, incidentally, was not just a blackmailing opportunist and a bloated hedonist, but was also an astute and sarcastic writer, a man of brilliant intellect who understood a great deal about art and aesthetics.

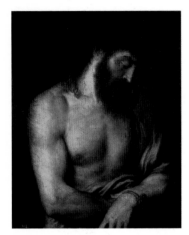

Ecce Homo, 1548

While it would undoubtedly be wrong to suggest, as Vasari did, that Titian's friendship with Aretino was motivated purely by self-interest, it certainly had its uses. For instance, when Titian spent several months in Augsburg in 1548, Aretino ensured that his friend's Venetian colleagues, most notably the ambitious Tintoretto, who hoped to turn Titian's absence to their advantage, were kept in check. In April of that year, Aretino wrote to Lorenzo Lotto, paying him compliments so back-handed that the recipient could only have taken them as mockery. Aretino passed on greetings from Titian, whose success at the imperial court he described in detail, adding that, of course, there was no envy whatsoever in Lotto's breast and that even though he might be the lesser artist, his piety was surely unsurpassed.

In short, with Aretino as his friend, Titian the prince of painters had the power of the 'press' behind him. And for that, he was grateful. When he brought the Emperor a painting of the *Ecce Homo* (*above left*) in 1548, he made another version for Aretino. Aretino, who had caused a scandal with the publication of a pornographic book, hung the devotional painting in his infamous bedchamber. The atmosphere in the room, according to Aretino, was thus transformed from a room of worldly power to a temple of God. The painting, he said, was a gift that turned pleasures to prayers and lasciviousness to respectability.

Jakob Seisenegger, **Portrait of Charles V with a Dog**, 1532, oil on panel, 203.5 x 123 cm, Kunsthistorisches Museum, Vienna

Aretino played a role we would describe nowadays as that of Titian's manager, promoting him at the princely courts. However, Vasari's claim that it was Aretino who organised the first meeting between the artist and Emperor Charles V in 1530 is incorrect. That had already been arranged by Federico Gonzaga.

Within the seven years following the Augsburg Imperial Diet of 1548 Titian's workshop produced seventy paintings for the Hapsburgs and their entourage. The Emperor is generally portrayed in full length, allowing him to present himself *in effigie* with his arms and the insignia of his power (*opposite page*). Titian's point of departure was a portrait type by the Austrian painter Jakob Seisenegger (*left*), which he adapted and imbued with a far greater degree of representational prestige. Titian was supremely capable of rendering the personal fragility behind the figure of power, as in his portrait of the

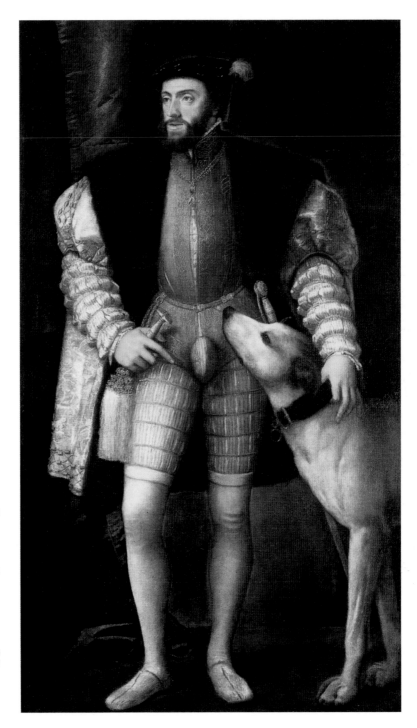

Charles V with a Dog, 1532/33

This famous portrait, now in the
Prado, showing Charles V with
a large dog, is clearly based on
a 1532 work by the Austrian
painter Jakob Seisenegger
(*opposite page*). In an age when
busts of worldly rulers were the
norm in portraiture, Seisen-
egger's full-length portraits of
refinement and dignity brought
him international fame in his
own lifetime. And yet, in adopt-
ing this formula, Titian has gone
so much further. His handling of
colour, in particular, lends the
work an atmospheric allure that
Seisenegger's more sombre
approach does not achieve.

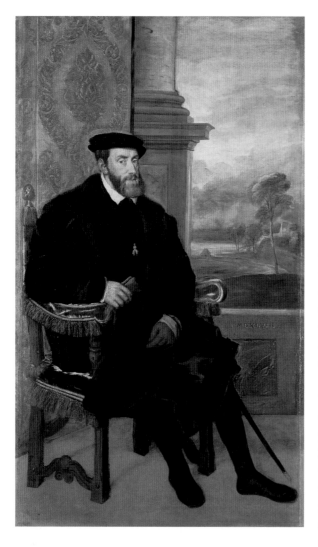

Charles V, 1548

Titian is most certainly the author of the key areas, notably the subtly rendered face and hands of the Emperor. Titian's pupil, however, the Netherlandish artist Friedrich Sustris, probably over-painted and completed some parts. Apart from the Order of the Golden Fleece, the Emperor has none of the attributes of power. Only the massive column behind him and the sumptuous brocade give any indication of an imperial aura.

Emperor in a Munich interior that shows a man aged beyond his years, wracked by gout and yet filled with calm serenity and dignity (*left*). Compelling as these portraits may be, all of them are overshadowed by the equestrian portrait of the Emperor, now in the Prado (*opposite page*). In the previous year, Charles had won a decisive victory over the Protestants at Mühlberg and he marked the occasion by having his portrait painted in full battle dress. Aretino, incidentally, took the credit for this *concetto*. What is more, he proposed a whole slew of learned allegories. But Titian saw no need for such academic overload, just as he also eschewed all direct references to war and victory, concentrating instead on the bare essentials. The Emperor, riding through a magnificent landscape, is elevated to Defender of the Faith, stylised as a Christian knight or *miles Christianus*, a second Saint George, a descendent of Constantine, the first Christian emperor, to whom the long lance refers.

The *musée imaginaire* of noble figures that Titian built up portrait by portrait recalls the art of description that Venetian envoys and diplomats presented in their reports from the centres of Europe. They keenly observed the people around them, accurately pinpointing their strengths and weakness, while at the same time invariably granting the subjects of their scrutiny the dignity of their rank, status and person. At first glance, the 1546 painting of *Pope Paul III and his Grandsons Alessandro and Ottavio Farnese* that Titian created during his eventful time in Rome seems to contradict such respectful reticence (see p. 81).

An inventory of the Palazzo Farnese in Rome drawn up in 1653 describes it succinctly as "a large unfinished painting on canvas in a wooden frame with the portraits of the seated Pope Paul III with Cardninal Alessandro Farnese and Duke Ottavio, both standing, paying their respects to the Pope." Although protocol dictated that all visitors to the Pope, whatever their rank, had to bow down to him three times and then kiss his feet, in this painting only Ottavio is in the process of kneeling before his papal grandfather. Alessandro confidently grasps the back of the chair, betraying his ambition to ascend

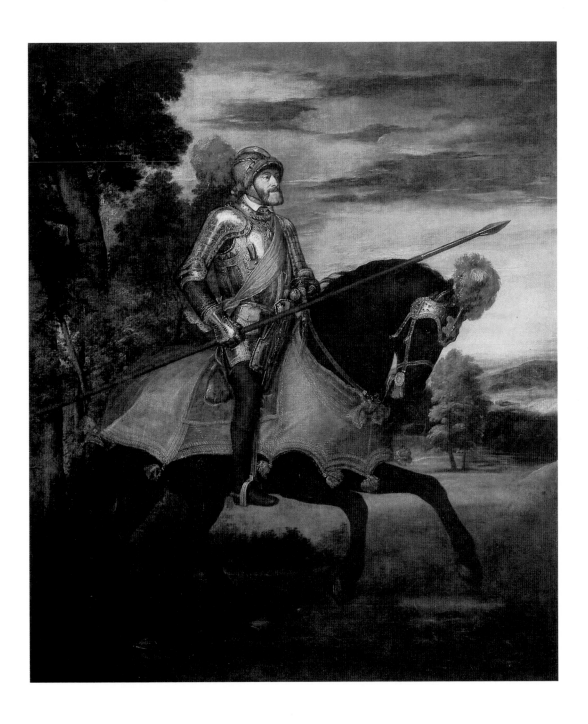

Portrait of Charles V on Horseback, 1548

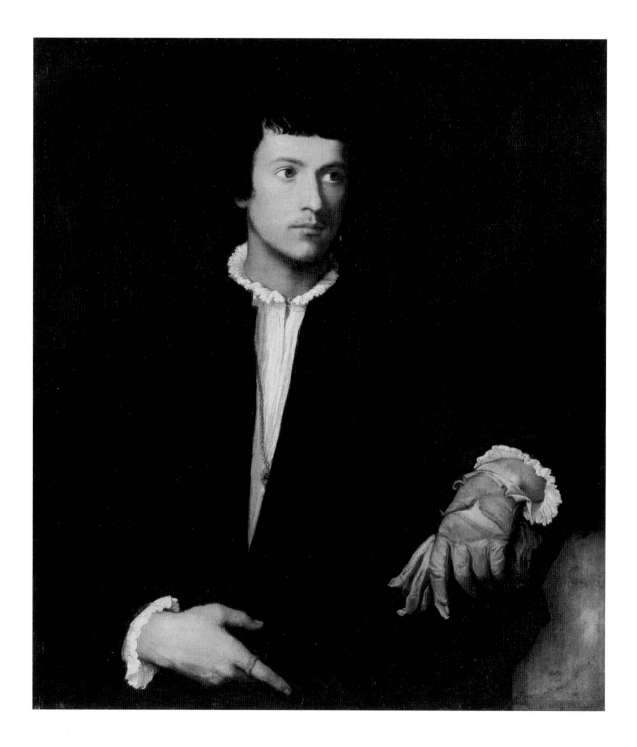

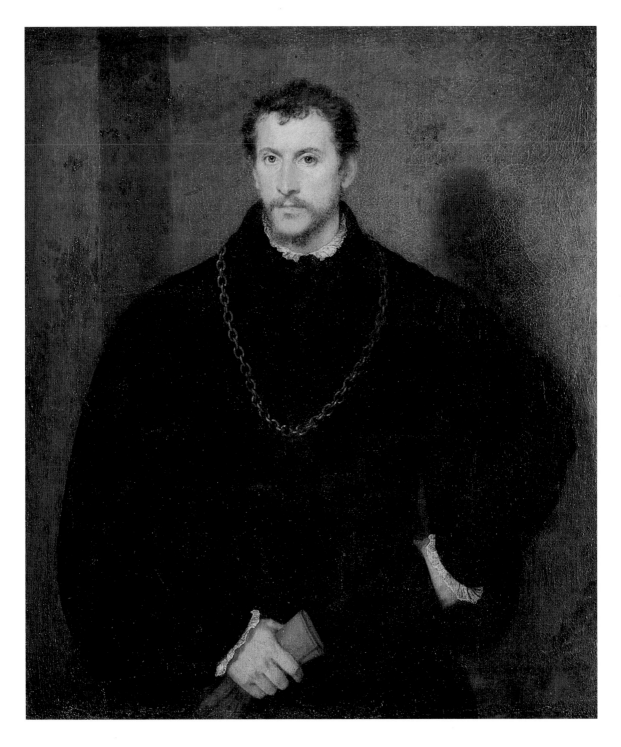

the papal throne himself one day. This motif is also foreshadowed by Raphael in his *Portrait of Leo X with Cardinals Giulio de' Medici and Luigi de Rossi* (left).

Titian's painting contains a number of political and dynastic insinuations. The Emperor is to be given the message that the Pope is respectfully turning towards the grandson who will one day take over the Duchy of Parma and Piacenza. It is Ottavio, who is also the son-in-law of Charles V. But Alessandro would never have allowed the brother he so hated to be the only one included in this scene. And so the compromise was made to include the cardinal in the family portrait.

A family portrait it undoubtedly was, this masterpiece so eloquently displays nepotism as a political tool legitimised by the curia. But the intrigues of a power-hungry Renaissance pope and the Farnese clan he protected precludes all thought of any family idyll. The face of Paul III speaks volumes. In it, we can almost read the reasons why so many notes lampooning a pope regarded as deeply corrupt were posted by night on the ancient marble statue popularly known as Pasquino. Aretino, who had written no small number of these so-called *pasquinades* himself, could not quite suppress a certain admiration for the man he referred to as the 'Roman lion'. Titian, too, was

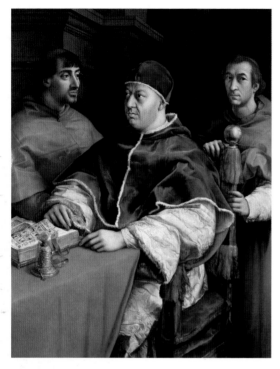

Raphael, **Portrait of Leo X with Cardinals Giulio de' Medici and Luigi de Rossi**, completed 1518, oil on panel, 154 x 119 cm, Galleria degli Uffizi, Florence

fascinated by his sitter – his frail hands are like claws about to pounce on their prey. The painting shows the personal drama of an old man struggling against death with stubborn energy by imposing his will on posterity, and demonstrates Titian's supreme ability to portray the psychology of power and the power of the psyche by means his subtle handling of colour. It is one of the most extraordinary experiences in the entire history of portraiture.

Pope Paul III and his Grandsons Alessandro and Ottavio Farnese, 1546

Page 78
Man with a Glove, *c.* 1520

Page 79
Portrait of a Man (the Young Englishman), *c.* 1540–45

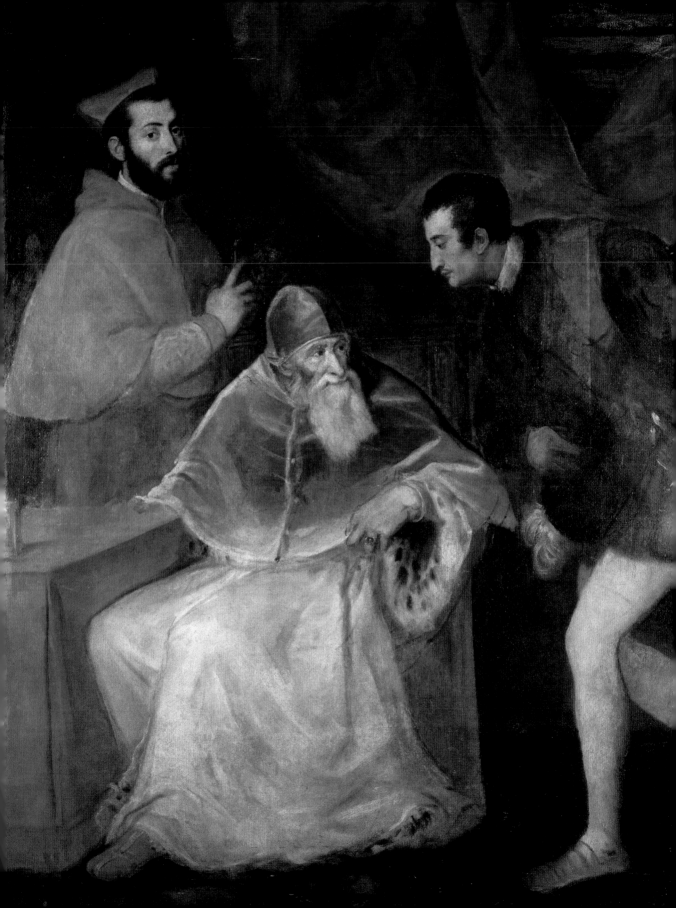

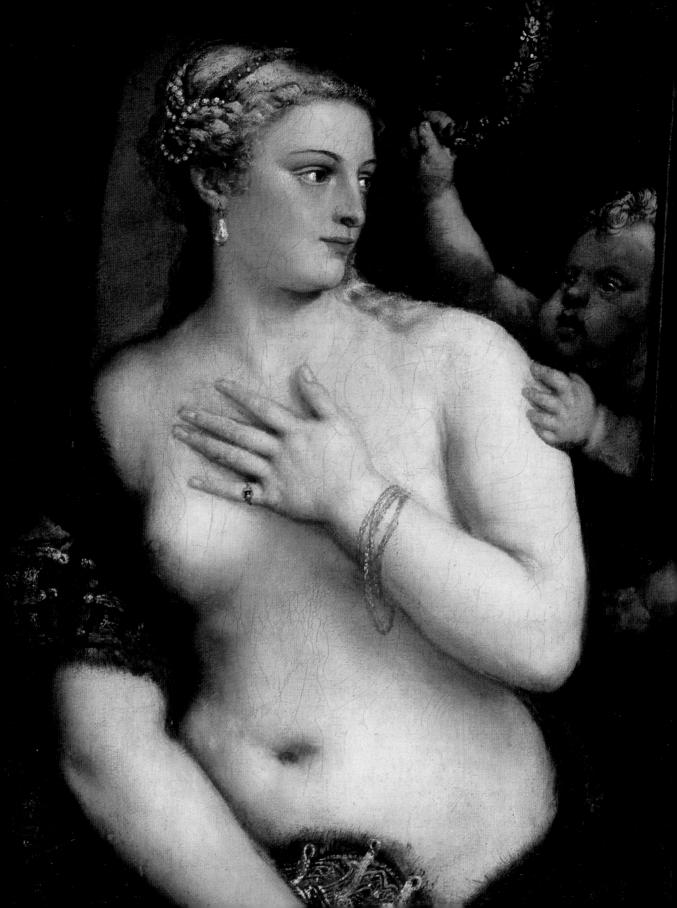

Eroticism and Sensuality

"For Duke Ottavio he painted a beautiful life-sized Danaë that Michelangelo saw and praised as unsurpassed, confirming that the handling of colour could not be bettered. ... Anyone of sound reason considers Titian peerless in the portrayal of the female body"

Carlo Ridolfi on the *Danaë* in Naples, 1648

Cardinal Alessandro commissioned one of the most celebrated of all the paintings in the Farnese Collections – the *Danaë* (*below*) now in Naples. On 20 September 1544 the papal nuncio in Venice, Giovanni della Casa, wrote to him saying: "... Titian has almost completed a naked female figure Your Eminence ordered that would put the devil into the Cardinal of San Silvestro." The cardinal he is referring to, for whom such a frivolous nude would be a diabolical shock, is the Dominican Tommaso Badia, one of the leading censors of the papal court. Della Casa goes on to point out that Titian could make the figure of Danaë even more appealing to Alessandro by giving her the facial traits of Donna Olimpia, a high-class courtesan with whom the cardinal was said to have had a relationship. In this way, the courtesan would be granted the honour not only of being physiognomically present, but also of reiterating Michelangelo's magnificent sculpture of *Night* in her recumbent pose (see p. 88).

Some ten years later, Titian presented another version of the *Danaë* to Philip II (see pp. 84/85), followed by a pendant piece, the painting of *Venus and Adonis* (see p. 97). It is interesting to note the reason the artist gave for putting these two together: "because the Danaë that I already sent Your Majesty is seen from the front, I wanted to make a variation in this new 'poesia' and show the other side of the body in order to enhance the room in which the paintings will be hung." This time, the cupid of the earlier composition is replaced by the figure of the nurse, her arms outstretched in greed to catch some of the 'golden rain' that implies a sexual act: lascivious Jupiter appears to Danaë in the form of a shower of gold and coins, for which she parts her legs. From this coupling, nine months later, the hero Perseus is born.

Della Casa could not resist remarking on the Farnese *Danaë* that the nude "which Your Eminence saw in Pesaro in

Venus at her Mirror (detail), *c.* 1550/60

Pages 84/85
Danaë, *c.* 1549/50

Danaë, *c.* 1545/46

Titian treated the Danaë legend several times. In the 1545/46 painting, he allegedly gave Danaë the facial traits of a high-class courtesan with whom Cardinal Alessandro Farnese is said to have had a relationship. Titian later sent another version to Philip II in which Cupid is replaced by the avaricious nursemaid.

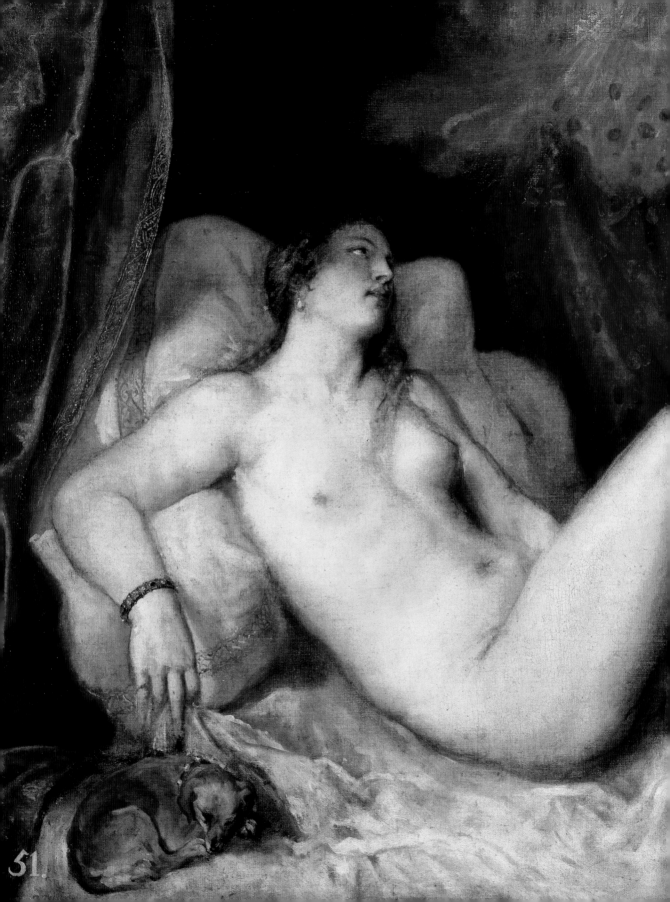

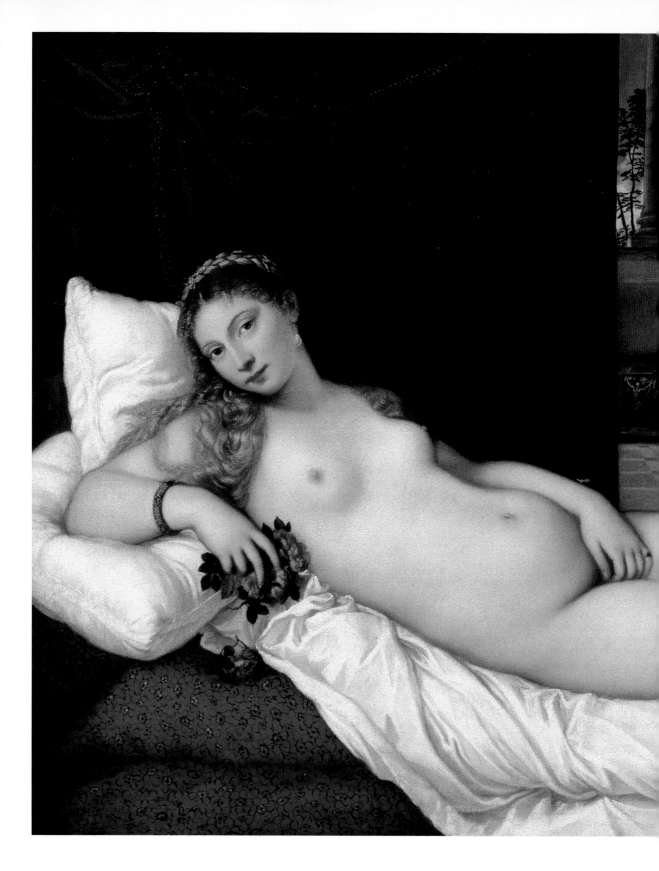

Venus of Urbino, 1538

In comparison to the Dresden *Venus* by Giorgione, Titian's later version of a reclining nude is more overtly erotic by far. Without the mythological references, its iconographic determination – courtesan, bride, Venus or pin-up girl – remains unclear. Since the first half of the seventeenth century, this painting, like the Medici Venus in the Uffizi, has been high on the list of sightseeing priorities for every visitor to Florence.

Michelangelo, **La Notte**, 1521–34, marble,
630 x 420 cm (overall dimensions of tomb),
Medici Chapel, San Lorenzo, Florence

This famous sculpture inspired the pose
of Titian's Danaë in the Madrid painting
(see p. 86).

the chambers of the Duke of Urbino is a Theatine nun by comparison." The 'nun' he was referring to was the so-called *Venus of Urbino* (see pp. 86/87).

In May 1538 the Duke of Urbino, Guidobaldo II della Rovere, pressed the dilatory Titian to complete the *donna ignuda* (female nude) that he had ordered some time ago. In this painting, which was delivered shortly afterwards, the motif of the female nude was clearly of central importance. It was not until decades later that the painting came to be described as a 'Venus'. Undoubtedly, the painting, which hung in the Duke's summer residence near Pesaro, was a response to the *Sleeping Venus* (*opposite page*) composed by Giorgione and completed by Titian, albeit with certain crucial changes: the background landscape has been replaced by an alcove and the cupid by a maidservant, a lapdog has been added and instead of slumbering, the main figure is awaiting her morning toilette – or perhaps her lover?

In 1787 the German novelist Wilhelm Heinse enthused in *Ardinghello, or, An Artist's Rambles in Sicily* about this "charming young Venetian girl of seventeen or eighteen, with her langorous gaze, on a hard white daybed in the fresh morning light, stark naked of any covering or drape, so warmed is she by an inner glow, reclining ready and willing to give and take lust; her hand, instead of shielding her, seeks to cool the piercingly ardent sweetness of desire as her fingertips touch the most arousing and tender nerves of her highest existence. A beguiling bed-mate instead of a Greek Venus, lust instead of love, a body purely for the pleasure of the moment … Titian did not mean to paint a Venus, but a lover, and what could he do about it that she came to be called the goddess of love?"

Titian sexualises Giorgione's reclining figure, on which the painting is based, by placing the hand of the woman between her legs and by shifting the vanishing point of the composition so that this gesture becomes the focal point. The work possesses a previously unheard of eroticism without any mythological props and provides no clue as to its iconographic intent or whether the woman is a courtesan, bride or Venus. Not for nothing was the *Venus of Urbino* in the Uffizi a must-see erotic attraction for any seventeenth-century visitor to Florence. The strength of its erotic appeal is indicated by the fact that a specially painted curtain was placed in front of it with a portrayal of *Sacred and Profane Love* as an imaginary protection against revealing Venus. This allegorical décor is meant to suggest that when the curtain opens upon the stage of the painting, the play we are about to see will be erotic, but not pornographic.

The art historian Charles Hope dismissed any such constraints by declaring the nude to be nothing more than a pin-up girl – especially given that Titian had used the same model for his *Girl with a Fur Wrap* (*opposite page, top*), now in Vienna, whose wrap has

slipped to reveal her breast, making her an object of voyeurism. Critics have accused Hope of an obscenely one-dimensional view that is tantamount to prostituting the young women in Titian's paintings. However well-founded such criticism may be, the opposite view, taken by feminist art historians such as Rona Goffen, who see in the *Venus* a demonstration of confident female sexuality, seems equally far-fetched. According to this school of thought, the ideal viewer of such a 'worldly' figure of love would be her husband in the bedchamber; Titian was thus portraying an ideal image of the married woman in which he paid tribute to the combination of chastity and sexuality as dual aspects of womanhood on the brink of emancipation.

Anyone hoping to find an answer to these questions in Titian's biography is bound to be disappointed. We do know that he already had two sons by Cecilia Soldano, a country woman he employed as his housekeeper, before they officially married in 1525. But that was nothing out of the ordinary at the time, let alone a sign of an excessively libidinous life. On the contrary, a letter of January 1553 from Aretino to the architect and sculptor Jacopo Sansovino, describes Titian as a man who enjoys flirting with women but never seeks intimacy with them. Aretino goes on to describe himself as a very different type of man who spends much of his time in brothels. Admittedly, some earlier reports accuse Titian of taking more than just an artistic and aesthetic interest in the women who sat as his models. Is this just studio gossip or is there some truth in it? Titian certainly knew the courtesan Angela del Moro, known as La Zaffetta, who was the victim of a gang rape instigated by a Venetian nobleman in 1530. But how close was their relationship really? Just how much did the notion of human weakness resonate in the environment in which Titian lived? The philosophy of love that informed the literature and visual arts of the day tended to romanticise women. Whereas in fifteenth-century

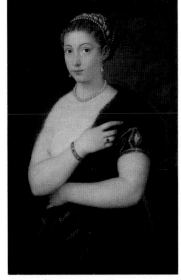

Girl with a Fur Wrap, *c.* 1535

The young woman seen here with her fur wrap slipping alluringly was painted several times by Titian, both clothed and unclothed. All the portraits of her were made for the Duke of Urbino. It is possible that she was a high-class courtesan. Rubens was later inspired by the eroticism of this particular portrayal to create a similar portrait of his own wife.

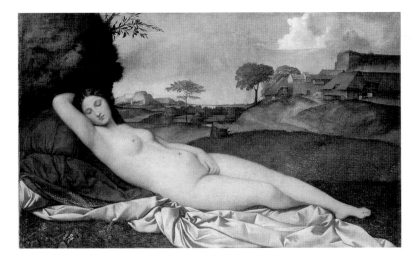

Giorgione and Titian, **Sleeping Venus**, 1508–10

Giorgione, who painted the greater part of this work, has adopted two classical compositional formulae in his rendering of the reclining nude. One is the *Venus pudica*, coyly covering herself with her hand. The other is the sleeping Venus. Titian's contribution here is mainly in the finely executed background landscape.

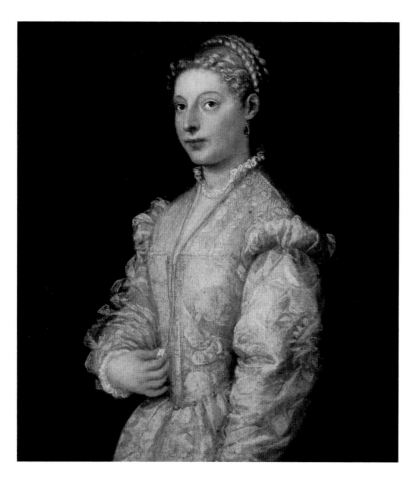

Portrait of a Young Woman, 1545/46

This young woman has been identified variously as Titian's daughter Lavinia and as a courtesan of Cardinal Alessandro Farnese by the name of Angela. During World War II, Goering had this canvas removed from Montecassino Abbey to be held in the mine shaft near Bad Aussee, Austria, where the Nazis stored the works of art they had seized throughout Europe. It was returned to the Naples collection in 1947.

Florence, with the exception of the paintings by Botticelli, it was the male figure that was the main focus of mythological and even erotic imagery, in sixteenth-century Venice that role was increasingly occupied by female figures. In Titian's works, as in Venetian painting in general, we find a distinctly seductive type of woman emerging to replace the male figure as a model of human beauty in art.

The beguiling figure of *Flora* (*opposite page*) in the Uffizi, for instance, is not only of uncertain date, but is also the subject of divergent interpretations as to the meaning of her dress and floral attributes: bride and courtesan alike. We have no way of knowing whether the young women who were Titian's models for many similar paintings were maidservants, courtesans or ladies of rank. Old inventories tend to document them simply as *donna* or *bella* – clearly a woman's beauty was more important than her name. Modern art historians, in applying the epithet 'Flora' – a name whose associations with the goddess of spring emphasises the youthful girlishness of the figure – clutch at a compromise between private and mythological eroticism.

Let us test this thesis by way of example of two paintings of women that Titian produced for the court of Urbino in 1536. One is known today as *La Bella* (see p. 92) and shows a young woman dressed in blue. The other is a portrait of Duchess Eleonora Gonzaga (see p. 93). The clothing and physiognomy of both bear certain similarities – which makes the differences between them all the more striking. The face and pose of Eleonora Gonzaga, once celebrated throughout Italy for her beauty, show her as a woman marked by age and resignation. She seems to be a prisoner of her rank and status, fettered by the rules and regulations of courtly etiquette. *La Bella* goes against the dictates of portraiture for women of high nobility. Discreetly, but nevertheless distinctly, the line of her décolleté emphasises the roundness of her breasts, while a lock of hair has come loose from her intricate coiffure and trails tantalisingly over her shoulder. These small

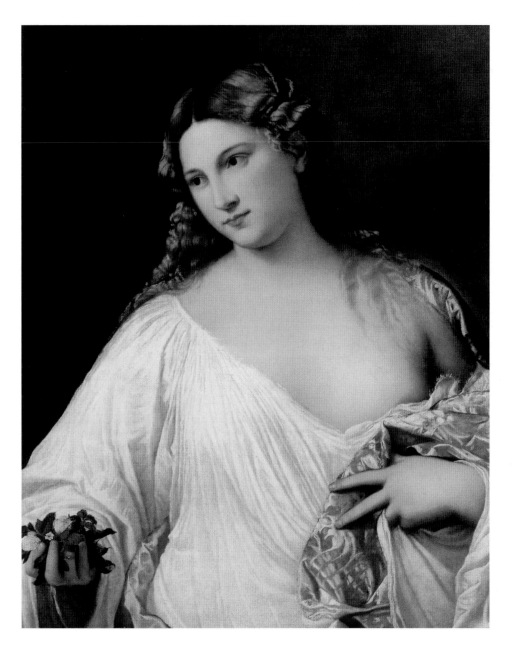

Flora, *c.* 1515

This painting is generally dated to 1515 but sometimes to 1510 or, at the latest, 1522. The scantily clad young woman with flowers has variously been interpreted either as a bride on her wedding night or as a courtesan. We do not know for certain what Titian's own attitude to romantic dalliances was. A letter written by Aretino in January 1553 describes him somewhat ambiguously as a man who flirted with women but never actually sought intimacy with them.

Eleonora Gonzaga, 1536

Portrait of a Lady (*La Bella*; detail), 1536

liberties achieve a blend of dignity and intimacy. Whether this painting shows a woman from the courtly circles or a Venetian beauty or even a woman of the night, cannot be discerned. It remains the subject of much speculation.

The rhetoric of seduction and eroticism in these works that were so popular among the nobility cannot be denied. Many of them hold up an unequivocally ambiguous mirror to the prospering profession of the Venetian courtesans, those servants of love who were often styled as courtly women – much in the manner in which Aretino described a clever courtesan's attitude to her customers: "I made as coy as nun, looked at them as directly and openly as a wife and as I did so I behaved like a whore." The Washington *Venus at her Mirror* (*opposite page*), for instance, might well have been a portrait of a courtesan in the guise of a mythology painting. Yet the realism, beauty and depth of meaning in her contemplation of herself in the mirror tells us that Titian did not simply see women as superficial creatures whose sole purpose was to be pleasing to the eye. It is primarily the implicit or explicit mythological aspect that lends his portrayals of them unfathomable, semantic depth.

Titian called his interpretations of mythological life and gods *poesie*. Not without reason, their dramatic composition and their rich sensuality rooted in existential enigma have been compared to the writings of Shakespeare. Though the cycle of mythological *poesie* that Titian completed in the 1520s for the court of Ferrara brought great acclaim, the paintings he did for Philip II were nothing short of a sensation. The cycle began with the 1554 *Venus and Adonis* and ended with the 1562 *Rape of Europa* (both p. 97).

Venus and Adonis was occasionally criticised, though mainly praised, for the fact that Titian had ignored Ovid's description of Adonis setting out on his fateful hunt only after Venus had left. Titian's concept was seminal in changing the artistic and literary understanding of a certain iconography. His painting established the departure of the hunter as the *peripeteia* – the tragic turning-point in the relationship between the lovers. Judging by the number of copies and variations on this picture, *Venus and Adonis* was the most successful composition Titian ever painted. In 1557 Lodovico Dolce dedicated the most detailed analysis in the whole of early Venetian art literature to this work. The *morbidezza* of the goddess' body, which, though beautiful, is no longer attractive to Adonis, her clinging embrace from which he desperately seeks to extricate himself, the echo of her pain in the thundery sky: all these harbingers of disaster taint what was once an idyll of love.

When Titian painted this work for the Spanish court, he recalled Correggio's *Jupiter and Io*, which he had seen in Mantua. But Titian has transformed Correggio's passively recipient female figure into a passionately active one trying to cling to something that cannot be saved. The futility of her attempt is also expressed in the fact that Adonis is rising to leave in the opposite direction from the one in which Venus so seductively parts her legs.

Venus at her Mirror, *c.* 1550/60

Copied and paraphrased many times, both by Titian's own workshop and also by Tintoretto, Veronese, Rubens and others, this magnificent celebration of female beauty quickly became famous.
The goddess of love is portrayed here in close-up, the shimmering flesh tones of her naked torso drawing the viewer's gaze. Venus is admiring herself in a mirror held by a cupid. Another putto touches her upper arm and hands her a wreath of myrtle. The reflection in the mirror shows mainly the left-hand side of the goddess' face, which is not visible in the profile view of the actual figure. The most striking aspect of this painting is the way the woman's eye in the mirror arrests the gaze of the viewer.

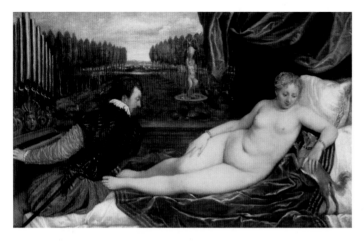

Venus and the Organ Player, 1548/49

Nowhere in Italy does Venus, the goddess of love, seem to have been more widely celebrated in poetry and painting than in Venice. In this portrayal of the reclining goddess, Titian has combined two compositional types to create a brand new theme that soon became popular among wealthy collectors. This particular painting is documented early on in the collection of Cardinal Granvilla, a state minister of Emperor Charles V.

Page 97, top
Venus and Adonis, *c.* 1555

The theme of Venus and Adonis was what we would now term a best-seller. The original version (no longer extant) is thought to have been painted in 1545/46 for the Farnese family. More than thirty painted and engraved variations and replicas exist, all of them associated with Titian's workshop.

Page 97, bottom
Rape of Europa, 1559–62

Another innovative aspect of Titian's portrayal of Venus is his inclusion of a musician, a figure that can also be found in at least six versions of the goddess of love. This subject, which is not part of the ancient myth, continues to prompt speculation. The paintings in Berlin and Madrid show a nobleman playing an organ and turning to gaze at the seductively reclining Venus who is devoting her attention to her son Amor or a lapdog. The Madrid painting differs in that it is the first in which the goddess shows herself without a cloth over her loins, and also in the musician's gaze being directed at her lower body.

Recent art historians have noted that Titian, himself a talented musician, portrays the complex affinities between love for a beautiful woman, its literary expression in poetry, its musical expression in the madrigal and the beauty of harmony experienced in the enjoyment of music – either by showing a musician finding inspiration in the appeal of the woman he is observing, or by showing him being distracted from the music by her sexual charms. This would explain the presence of the head of the Medusa on the front of the organ in the Madrid painting: both as a suggestion that infatuation can incapacitate those blinded by love as though they were turned to stone, and also as an art theoretical *topos* addressing the brilliant painter's ability to capture a scene. Like the musician in the painting, the spectator, too, is meant to be captivated, as though 'turned to stone' by the sight of the female beauty rendered by Titian.

Because of its subtlety and depth, Titian's visual eroticism has no need to shy away from scenes of high drama. In the *Rape of Europa* (*opposite page*), the female figure, neither beautiful nor chaste, is wrenched around on the side-saddle of the bull (the guise chosen by Jupiter to abduct her) so that she is prostrate in a position of uninhibited physical abandon; the putto above the dolphin cheekily mimics her. The surrounding landscape embeds this scene within a seemingly cosmic context, evoked to some degree by the handling of colour, the blending and 'marriage' of the pigments.

Three times within the space of only a few years, Titian painted an Ancient Roman rape scene. He sent the first of these, *Rape of Lucretia* (*Tarquin and Lucretia*) (now in Cambridge), to Philip II in 1571. Titian justifiably announced his *Lucretia Romana uiolata da Tarquinio* as a great achievement, for the rape scene had rarely been the subject of a composition in its own right before, and had certainly never been portrayed so explicitly. The existential nature of love implies extremes, as in this display of sexual violence towards a woman. Titian had acquired the necessary compositional means to be capable of treating such extremes visually.

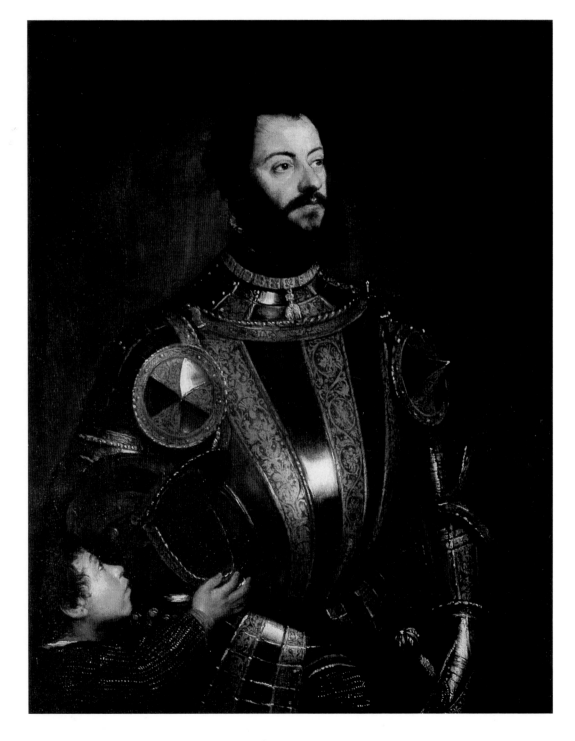

In the portrayal of the human body, what interested Titian, as the art literature of his day already points out, was not primarily the proportions or the muscles, but first and foremost the materiality, the softness of the flesh and the tenderness of the skin. This was echoed in the way he used the paint. The materiality of the paint itself was as important to him as the phenomenon of *colorito*. He would apply as a transparent scumble and as a thickly pigmented *impasto*. In this respect, Marco Boschini's comments of 1674 provide a valuable insight:

"Giacomo Palma the Younger (so called to distinguish him from the other Giacomo Palma, called the Elder), who had still had the good fortune to enjoy the teaching of Titian himself, has told me that Titian first laid down for his pictures a mass of colour which served, so to speak, as a bed or foundation for what he was then to depict upon it. … Having thus laid down this precious foundation, he would turn the pictures to the wall and leave them thus, sometimes for several months, without looking at them. And when he was again disposed to put the brush to them, he would observe them sternly, as though they had been his greatest enemies, to see whether he might find some defect in them. … And thus he gradually covered these quintessential compositions with living flesh, returning to them again and again, until they lacked only breath to make them live. … But the climax of his final touching-up he effected by blurring the outlines of the highlights with the tips of his fingers, bringing them down towards the half-tints and melting one colour into another; at other times with a touch of the finger he would darken the colour in some corner, to strengthen it, or lay on a streak of red, as it were a drop of blood, to lend vigour to some inexpressive portion; and thus he brought his lively figures to gradual perfection."

In Titian's *imprese* we find an interesing expression of the parallel between art and nature that Boschini described in sensualist metaphors: a mother-bear licking her cub. The ancient notion that the newborn cub was amorphous matter that the mother then quite literally licked into shape, is applied here to art. Titian's work measures itself against nature and even surpasses nature in that it spreads the fame of all it portrays and saves it from transience – this at least is one interpretation of the allegories of time and fame to the left and right of the mother-bear. In spite of its ambiguity, the motto NATURA POTENTIOR ARS, which can be read either as 'art is stronger than nature' or 'through nature art becomes stronger', always aims at one thing: breathing life into natural and artificial creation alike.

Nature and art in all their facets flow with the rhythm of life through Titian's female figures, irrespective of any boundaries drawn by society between morality and immorality. Small wonder, then, that Titian paid such special attention to the figure of Mary Magdalene. On 5 March 1531 he was commissioned by Federico Gonzaga to paint an image of the sinner and penitent and was instructed to make her 'as tearful as possible' (see p. 101). Federico had intended the painting as a gift to Alfonso d'Avalos, the

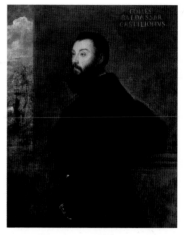

Portrait of Baldassare Castiglione, *c.* 1540

The writer and diplomat Baldassare Castiglione was instrumental in fashioning the image of the ideal Renaissance man in his book *Il libro del cortegiano* (The Book of the Courtier) published in 1528. His notion of *sprezzatura* – seemingly effortless achievement – had both a metaphorical and a practical influence on the 'sketchy' style of painting that Titian developed in later years.

Alfonso d'Avalos with a Page, 1533 (or later)

Alfonso d'Avalos, Marchese del Vasto, was one of the most brilliant military leaders of his day, securing Venetian victory over the Turks at Tunis in 1533. From 1538 until his death in 1546 he served Charles V as governor of Milan. Titian placed this celebrated Venetian hero at the right-hand edge of the Vienna *Ecce Homo* (see p. 72) alongside the Sultan as a virtual witness of his legendary defeat of the Turkish forces.

99

Penitent Magdalene, *c.* 1565

Titian painted several versions of this bibli-
cal subject that lends itself as a vehicle for
male fantasies. All of them are half-length
portrayals of the saint, clothed or un-
clothed, in a pose which, apart from the
tearful, heavenward gaze, is reminiscent of
a classical sculpture of Venus. The fact that
Titian's later versions, such as the one in
Naples, are less erotic – the saint is clothed
and has such attributes as a skull and bible
– may be due to the prevailing religious
and spiritual climate of the Council of Trent
and the Counter-Reformation.

Marchese de Vasto. But on 11 March 1531 he promised it instead to Vittoria Colonna,
the widowed Marchesa di Pescara. Vittoria Colonna was a famous poet who counted
among her friends Ariosto, Paolo Giovio, Baldassare Castiglione and, from the mid-
1530s onwards, Michelangelo. What is more, she did much to assist penitent courtesans
who placed themselves under the protection of Mary Magdalene.

Titian's bare-shouldered, bare-breasted Magdalene with her magnificently flowing
hair became a prototype for an entire epoch, though Titian himself did modify the motif
several times from 1550 onwards. The new type (*left*) actually heightens the eroticism:
only the right shoulder can be seen bare and the 'sinful' hair is less unruly, while the skull
is added as a sign of mortality and the open book as a sign of the *vita contemplativa*.
These ascetic elements are emphasized in such a way that they can only be read as ref-
erences to the growing ecclesiastical reform movement under Pope Paul III Farnese, the
'Roman lion' of Titian's portrait who, for all his intrigues, was also a protector of the
Jesuits and a supporter of Catholic church reform.

Mary Magdalene, 1531

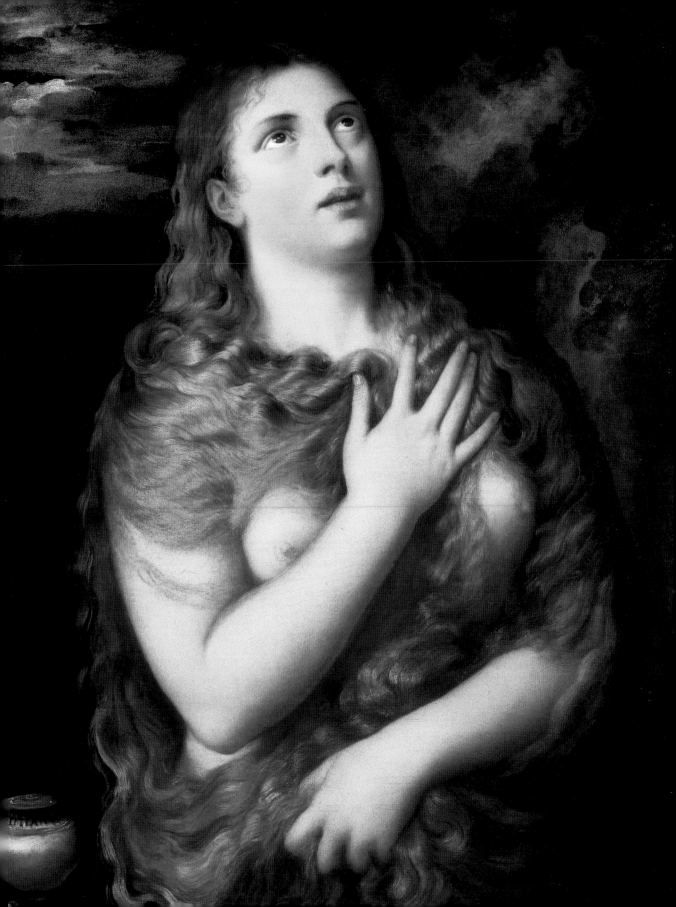

The Prince of Painters

"... out of the hands of Titian only wonderful and magnificent things can be created, ... our expectations have been exceeded by far, for his work is perfect and supreme. It is as though we had never seen anything so beautiful before."

Federico Gonzaga in a letter to Benedetto Agnello, Mantua, 19 April 1531

Did Titian temper the eroticism of his St Mary Magdalene, putting the image on a more discreet semiotic plane, simply in response to the mood of the Counter-Reformation, or was he actually making a personal statement? Had his own experience of violence, suffering and pain perhaps heightened his religious sensibility? He had, after all, seen his brother Francesco return wounded from the War of Cambrai. Two of his servants had been murdered soon afterwards. On 5 August 1530 his thirty-one-year-old wife Cecilia had died following the birth of their daughter Lavinia. His son Orazio had seriously injured the sculptor and medallist Leone Leoni in a brawl in 1559. What is more, the city itself was regularly swept by the plague, which was the cause of death of several friends and acquaintances.

Did such blows of fate prompt the highly successful artist to seek new paths towards religion? We know that Antonio Cornovi, the patron who commissioned the San Salvador *Annunciation* (see p. 32), consorted with heretics (though this does not necessarily mean that he shared their views). For a long time, intellectuals in Italy, both worldly and clerical, made little distinction between notions of Catholic ecclesiastical reform and the ideas of the Reformation as such. Venice in particular, a city of book printing and international trade where Protestant merchants from Nuremberg and Augsburg played an important role, was so open to the new ideas that one observer felt able to report to Luther in 1528 that 'the Venetians are accepting the Word of God'.

It was long thought that Titian himself belonged to the reformist camp and that this could be deduced from his *Deposition of Christ* (see p. 104) now in the Prado. It was even said that the artist had created a self-portrait in the figure of Nicodemus in this painting. In those days, he would indeed have been treading on thin ice had he made such a role portrait. After all, the reformist Calvin had used the term Nicodemites to describe those of his followers who lived under Catholic rule without openly admitting their faith, because of the fact that Nicodemus had come to Jesus secretly. However, it is by no means certain that the figure is a self-portrait of Titian, nor indeed whether it is even

Allegory of Prudence (Allegory of Time), 1565

In order to understand the three animal heads in the picture, we have to delve into the dark realms of Egyptian or pseudo-Egyptian mystery religions that had stirred so much interest among humanist scholars since the discovery, in 1419, of the esoteric *Hieroglyphica* manuscript attributed to the fictitious Horus Apollo, or Horapollo. With the *Hieroglyphica*, Serapis, one of the greatest gods of Hellenistic Egypt, had come back to life again after almost one and a half thousand years and had, by the time of this painting, become familiar from many old portrayals as a figure accompanied by a three-headed monster, entwined by a snake, bearing the heads of a dog, a wolf and a lion on its shoulders.

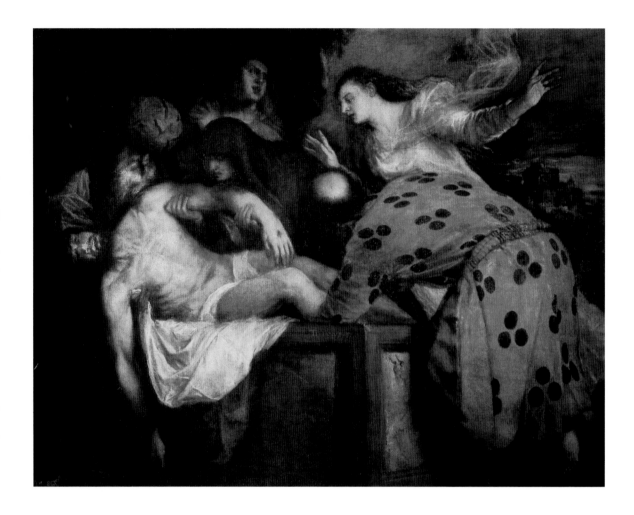

Deposition of Christ (The Entombment),
c. 1566

In this painting, now in Madrid, Titian has included a self-portrait in the guise of Nicodemus (or possibly Joseph of Arimathea) gazing with devotion upon the face of the dead Christ. However, this does not necessarily indicate, as some have suggested, that the artist was ever a follower of the heretical Nicodemites, active in Venice at the time, who paid lip service to the Catholic church while secretly espousing other beliefs.

the figure of Nicodemus at all but perhaps Joseph of Arimathaea instead. Moreover, not every portrayal of Nicodemus in a religious scene in those days was necessarily a reference to Nicodemites.

Titian's tax returns of 1566 show that he sublet the lower floor of his house to the heretic Zan Andrea Ugoni of Brescia. But that apparently did not give the Inquisition any grounds to extend their enquiries to Titian himself. Just where the artist stood in the battlefield between orthodoxy and hereticism remains a moot point.

In this regard, as in so many others, Titian's biography offers few answers. His paintings, however, tell us more. For example, Titian delivered an image of *Ecce Homo* to the Emperor in 1548. He later delivered a *Mater Dolorosa* (*opposite page*) as a pendant piece, which, if displayed as intended, would have shown the Virgin glancing over to her son.

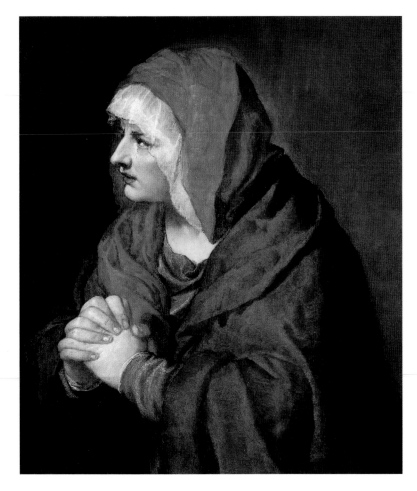

Master Dolorosa, 1554

Tititan created a pendant to this portrayal of the Mater Dolorosa in the painting of her son as Man of Sorrows (see p. 74). Emperor Charles V took both paintings with him when he abdicated and entered a monastery, but they have suffered considerable damage over the years.

The imagery is dominated by facial traits contorted in pain and eyes red from crying. The interaction between the figures is not determined by pious devotion and pathos-laden hand-wringing, but by a state of suspense. None of this suggests a dogmatic or heretic battle of faith, but rather, a profoundly earnest and quite conventional personal piety, both on the part of the artist and the patron. The two devotional paintings also bear witness to the compositional virtuosity of a painter fully aware of his own talent, who had long since become the prince of painters and whose potent and innovative compositions, peerless as they were, caused a sensation in every genre of painting. Titian had a network of influential friends and powerful patrons in the courts of Italy and Europe but kept at a certain remove from the constraints of courtly life, remaining a citizen of Venice all his life. This allowed him to be true to his artistic conscience.

Titian had reached the apex of success. This is also reflected in his financial situation. Vasari calculated that, as a knight and a count palatine, Titian had an annual allowance of 200 scudi in 1568, plus a further allowance of 200 scudi since painting the portrait of Philip II, and that he received an additional 300 scudi from warehouse fees, so that he "enjoys without too much effort a fixed provision of some seven hundred scudi every year." His profits from the sale of paintings were even higher still. When Titian drew up an inventory of his assets in 1566 for the Venetian fiscal authorities, his property included the studio house in Biri Grande, which he had purchased, a house in Col di Manza and a house in Conegliano. Since taxation was based solely on real estate, no other source of income is listed here – neither the allowances, nor the warehouse fees, nor the income from a timber business on the Zattere. For this reason, his inventory has on occasion been regarded as a prime example of tax evasion. Towards the end of his life, especially (when the Spanish envoy Hernández remarked that "he has become a little greedy with age"), the artist increasingly sought remuneration in kind rather than charging a fixed monetary fee for an individual work "for my support and that of my children." Occasionally he would accept a modest payment, such as building stones for the house in Col di Manza. For the frescos painted in the church of Pieve di Cadore in 1567, executed by one of his pupils, Titian accepted payment in the form of several loads of timber.

Titian's fame was also reflected in contemporary writings on art. For Paolo Giovi, around 1523, it was imperative to mention his name and study his works. Pietro Aretino never tired of referring to him, as we have already seen. In the third edition of his *Orlando furioso* in 1532, the writer Ariosto, who had known him since 1518 when they had met at the court of Ferrara, ranked Titian among the most illustrious of Italian painters and sculptors. Antonio Brucioli's second edition of the *Dialoghi* describes discussions held at his home between the painter and the famous architect Sebastiano Serlio about the physical and optical nature of the rainbow. It has often been remarked how insistently Lodovico Dolce evoked Titian in his *Dialogo della pittura*, not to mention the inclusion of his biography, albeit with some prejudice and aversion, in Vasari's *Lives of the Artists*.

These and later art-theoretical statements have tended to emphasise Titian's strikingly distinctive painterly style. From the 1540s onwards, in particular, the artist became increasingly interested in the phenomenal aspects of the material. He preferred to use roughly woven canvases whose thread patterns could be seen in the painting. The gestural mark of the brushstroke on the paint became an increasingly important element in the overall effect. In the course of an experimental production process that often lasted several years, Titian would change the initial concept with the result that such works have a sketchy, unfinished character. The fact that the boundaries between design and execution became increasingly fluid is not to be confused with the notion of

Martyrdom of Saint Lawrence, after 1557

In its original location in the second chapel in the right-hand aisle of the church that was demolished in the Baroque to make way for the new church of I Gesuiti in Venice, the evocative power of this monumental altarpiece must have been far greater than it is today, as anyone approaching from the main entrance would have looked straight at the saint, while the shovel stoking the fire and the intense glow of the flames would have been at eye level.

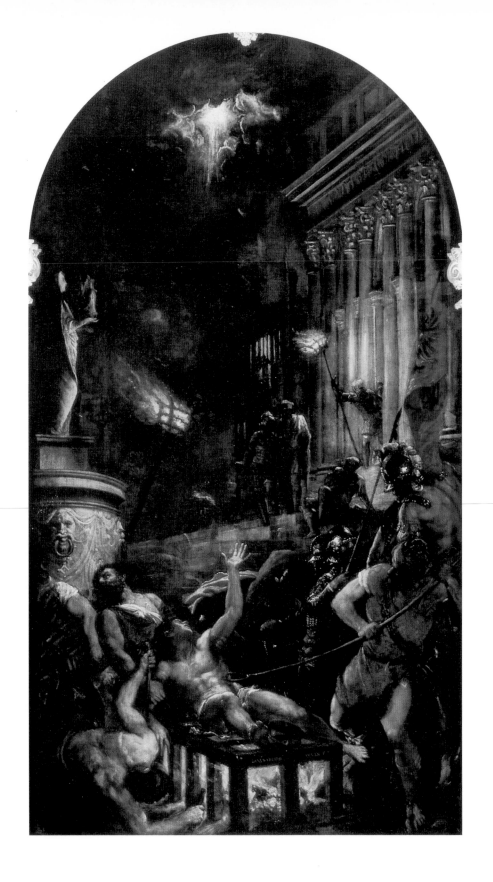

sprezzatura, or rapid and effortless artistry, that the art writers of the sixteenth century propounded, as did Baldassare Castiglione in his Book of the Courtier (*Il Cortegiano*). Titian's painterly style is only superficially the result of such *sprezzatura*. In reality it is the result of an exploratory working method that is anything but effortless. Restoration of his *The Flaying of Marsyas* (see p. 110), for instance, revealed that it was made up of no less than thirty layers of paint. Titian's eschewal of precise preliminary studies in favour of an orchestral wealth of colour and painterly devices went against the grain of the Florentine theory of *disegno* that insisted on the precedence of the line and the design over the 'mindless sensuality' and 'mendacity' of *colore*, thereby claiming the superiority of Florentine painting over the style practiced in Venice.

The firmly established notion of an artist's 'mature style', which is sometimes regarded in terms of physical deficit and sometimes in terms of a spiritual power drawn from the depths of human existence, is to a large extent rooted in the development, over many years, of Titian's increasingly painterly compositional approach.

In 1568 the art dealer Niccolò Stoppio wrote to the Augsburg merchant Max Fugger that Titian's eyesight was failing and that he was leaving the completion of his paintings more and more to his workshop because of his trembling hands. The imperial Spanish envoy reported from Venice in 1557: "I fear that Titian is too aged to produce good painting now. Yet his trembling hand does not banish the atmosphere and spirit from his paintings, even though they may prevent him from placing the colours and other details as well as he might do with a surer hand." Vasari, on the other hand, had little more than pity left for Titian's late works, claiming that "he would have done well in his last years not to have worked except as a pastime to avoid damaging with less skilful works the reputation he earned in his best years before his natural gifts had begun to decline." Vasari's polemical remarks were a counterblast against Venetian attempts to set Titian on a par with, or even above, Michelangelo. But Vasari would not be Vasari if he did not contradict himself elsewhere, citing the ideology of *sprezzatura*: He says of Titian that "his last works are executed with such large and bold brush-strokes and in such broad outlines that they cannot be seen from close up but appear perfect from a distance. … And this technique, carried out in this way, is full of good judgement, beautiful and stupendous, because it makes the pictures not only seem alive but to have been executed with great skill concealing the labour."

A few art historians, buoyed up by the remarks of those contemporaries who misunderstood and denigrated Titian's late work, sought to 'demystify' the artist by dismissing his last paintings as quite simply unfinished, as mere sketches or even as 'cheap'. This is contradicted not only by the ceaseless effort that Titian put into his late works, as revealed by recent technological studies: layer upon layer of paint bear witness to an almost obsessive process of change. Above all, it is contradicted by the fact that Titian continued in his old age to formulate epoch-making compositional solutions. One

Christ Crowned with Thorns, 1570

In this harrowing major late work by Titian, we cannot actually see the crown of thorns from which the painting takes its title. Even the figures wielding the sticks seem to be acting with little conviction. It is, however, the young man walking up the steps with his back to us that has provoked the greatest controversy: is he taking part in the action or is he trying to prevent it? He has sometimes been interpreted as a messenger sent by Pilate's wife, who was convinced of Christ's innocence. More recently, it has been suggested that this figure is a personification of Spain rushing to the aid of Christ and thus to the aid of religion – in other words, an appeal to Philip II to show his solidarity with Christendom under threat from the Ottoman Turks by joining the Holy League.

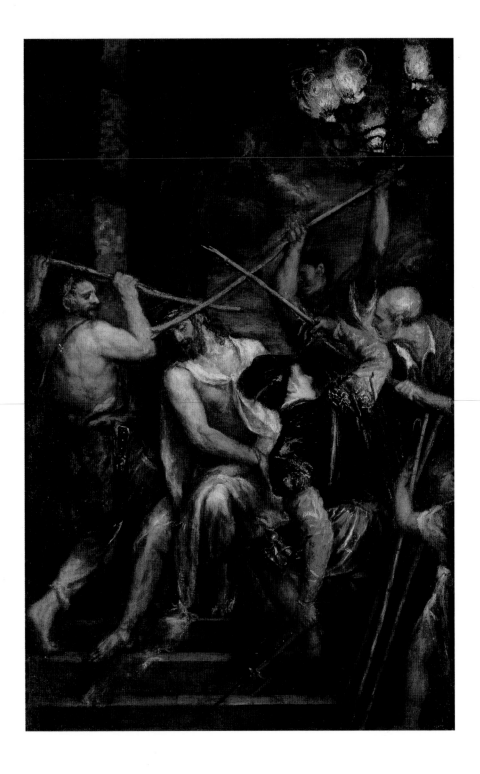

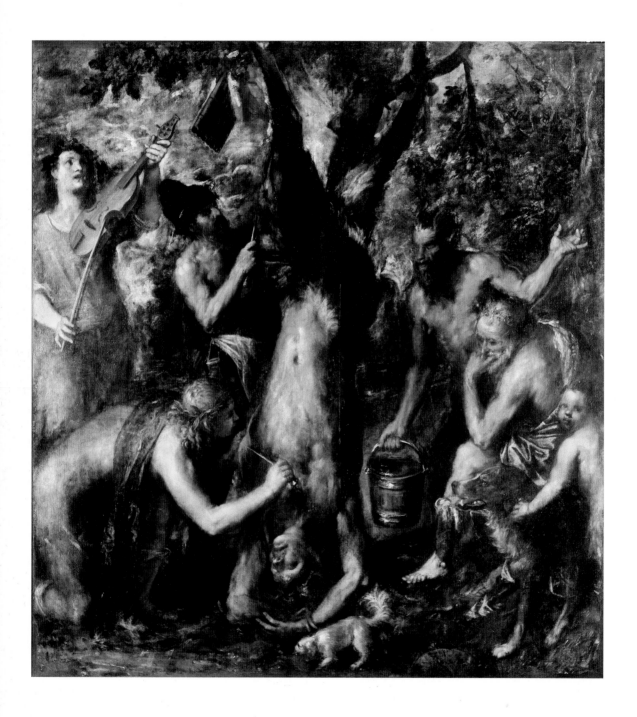

The Flaying of Marsyas, *c.* 1570

Saint Jerome in the Desert, *c.* 1575

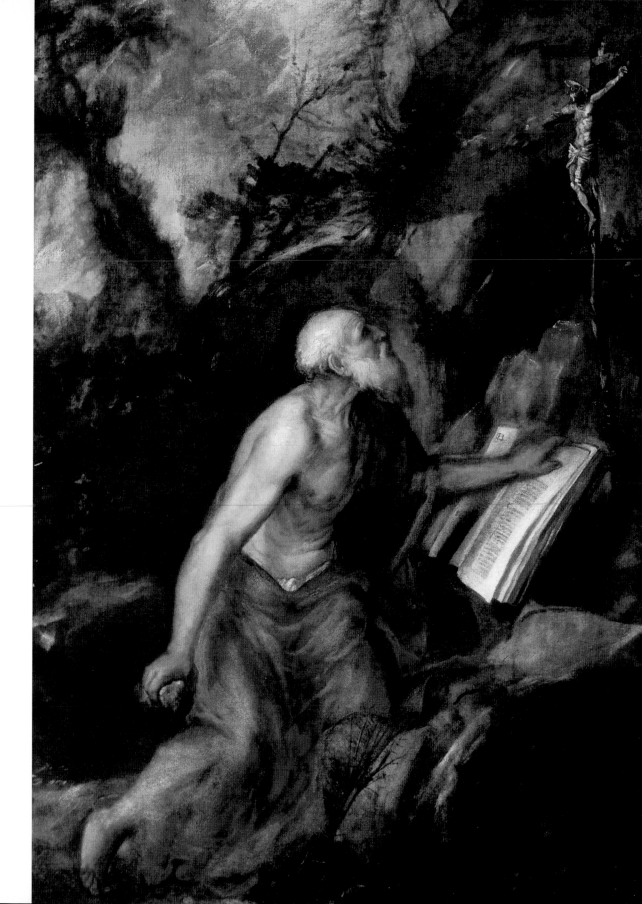

example that springs to mind is his *Martyrdom of Saint Lawrence* (see p. 107). Already begun in 1548, the altarpiece for the Venetian Chiesa dei Gesuiti appears to have been completed shortly after 1557. Its fame soon spread through descriptions and engravings and, in 1564, Philip II would have been content with a copy painted under Titian's supervision for El Escorial (he received a second version by the artist's own hand). Another example is his *Christ Crowned with Thorns* (see p. 109), now in Munich, which heightens the drama of an earlier version to become what is surely one of the most exquisite works of his late years.

Among Titian's magnificent late works *The Flaying of Marsyas* (see p. 110), with the same evocative power as the *Christ Crowned with Thorns*, stands out as embodying the very quintessence of Titian's art. This ancient myth tells of the punishment meted out by the gods to an impudent upstart. The silene Marsyas had dared to challenge Apollo to a contest of music. All the witnesses declared Apollo the winner – except the Phrygian king Midas, whom Apollo punished by making him grow the ears of an ass. But Marsyas paid an even more terrible price for his audacity – he was flayed alive.

Titian had recalled a fresco by Giulio Romano in the Palazzo del Tè in Mantua in which Marsyas is also strung up in the same way before the same group of onlookers. Titian has only added the two dogs – one lapping the blood from the floor, the other being restrained from biting into the raw flesh. Apollo is peeling the skin from Marsyas's chest, dissecting the body at the same time into a teeming mass of colour.

The relationship between perpetrator and victim has been interpreted in many different ways. To read it along the lines of a model of Christian martyrdom or in terms of neoplatonic idealism seems to miss the mark, for Titian offers no hint of redemption or divine intervention here. None other than the blond, curly-haired god himself is proving his superiority by flaying the silene with evident enjoyment.

Titian has painted his own portrait in the face of Midas. What could this possibly mean? Midas not only played a role in the story of Marsyas. There is also the well-known tale of how Dionysos granted him the wish that all he touched should turn to gold, and that it almost killed him because even food and drink were transformed into the precious metal. Was Titian referring here to Midas' greed, and thus responding to the criticism of his contemporaries about his own greed? Titian's Midas watches the flaying of Marsyas with a melancholy gaze – melancholy is traditionally the temperament of the artist. Midas appears in the midst of this dramatic event not as the foolish judge, but as though immersed in thought about the meaning and purpose of judgment as such. This would indicate a carefully calculated transformation into something positive, and thus Titian's own attempt at rehabilitation – that is if he did indeed see himself mirrored in Midas as an individual recognising certain human failings.

The scene, painted on particularly rough Venetian canvas, appears almost monochromatic. It is only on closer inspection that it reveals itself to be a wonderful symphony

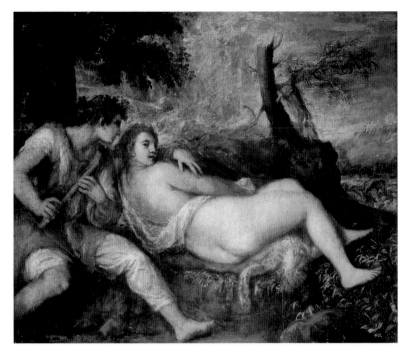

Nympha and Shepherd, 1570

As this painting, the last of Titian's so-called *poesie* was not a commissioned work, the artist had a free reign over the composition. What is unclear is whether he wished to present a well known mythological subject such as Daphnis and Chloë or whether the dramatic Arcadian setting and mysterious landscape was meant as an expression of man's bond with nature. Whatever his intention, it is the magic of colour that comes to the fore in this painting. Clarity of line, plasticity of form and smoothness of finish have been abandoned here in favour of a shimmering textural quality that melds man and nature in cosmic unity.

of deep chords, full of fine and richly nuanced subtlety, developed primarily out of the tonality of the flesh-tones, the 'skin' thus becomes the underlying theme, both in terms of colour and in terms of iconography. The epidermis, the texture of the painting, is made up of a vibrant orchestration of patches of colour that generate all shapes from their lively, breathing 'chaos'.

Only one of Titian's paintings bears a motto or 'titulus'. It says: Ex Praeterito / Praesens Prvdenter Agit / Ni Fvtvra Actione Detvrpet [From the past the man of the present acts prudently so as not to imperil the future]. This painting in the National Gallery in London now bears the title *Allegory of Prudence* (*Allegory of Time*) (see p. 102).

According to Panofsky the words *praeterito*, *praesens* and *futura* serve as labels for the three human faces in the upper zone, for the profile of the old man facing left, the frontal portrait of the middle-aged man in the centre and the profile of a beardless youth facing right. The physiognomic triad embodies the three stages of life – youth, maturity and old age – and with them the three modes of time: past, present and future. All-encompassing wisdom is comprised by memory that learns from the past, intelligence that passes judgment on the present and foresight. The three animal heads belong to the three-headed companion of Serapis, a monster entwined by a snake, with the heads of a dog, a wolf and a lion on its shoulders. These can be found regularly on Greek statues

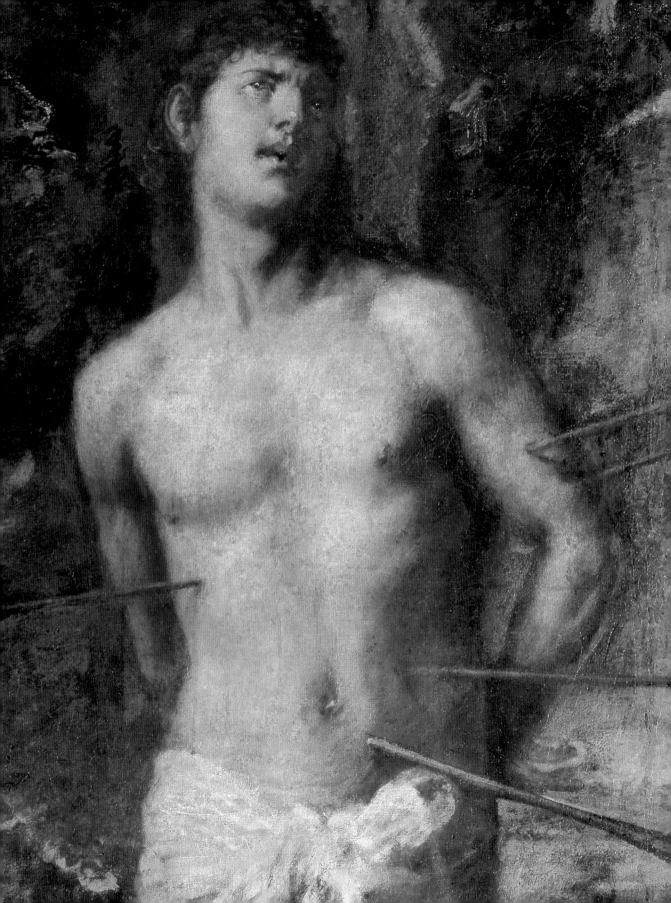

of Serapis. The lion's head symbolises the strong and fiery present, the wolf's head embodies the past because the memory of things past is devoured and carried away, while the head of the dog that seeks to please signifies the future, of which hope always paints a pleasant image, however uncertain it may be. The symbolic language here points towards the realms of Egyptian or pseudo-Egyptian religions that had become a renewed focus of considerable interest since the Early Renaissance.

In the face of the elderly man contemplating time past, Panofsky noted a striking resemblance to Titian, which he found confirmed by a comparison with the self-portrait in the Prado (see p. 132) that was painted around the same time. His son Orazio also plays a role here. Panofsky wrote: "If Titian's own face stands for the past and that of his son Orazio for the present, we would expect that the third, youthful face which signifies the future belongs to a grandson. Titian, unfortunately, had no living grandson at the time. But he had taken into his house, and carefully instructed in his art, a distant relative 'whom he particularly loved': Marco Vecelli, born in 1545 … True, Titians picture – combining the three animal heads recently linked to the idea of prudence with the portraits of himself, his heir apparent and his heir presumptive – is what the modern beholder is apt to dismiss as an 'abstruse allegory'. But this does not prevent it from being a moving human document: the proudly resigned abdication of a great king …"

Today's art historians, though they rarely find in favour of Panofsky's philosophical exegeses, have tended to accept his interpretation of this fascinating picture. But it is not only this three-headed image, this worldly trinity, that shrouds the work of Titian in enigma. There are, as we have seen, countless unexplained facets to his œuvre. His biography rarely, if ever, helps us in our quest to understand the underlying structures in the work of this artist who is now so justifiably regarded as an Old Master. 'I, Titian …': the ego of the artist that echoes in this phrase tends to be more concealed in his works than it is an aid to explaining them. What does it tell us that Titian was a man in pursuit of wealth and success? The question is why. Courtly patronage may have offered him ideal opportunities of upward mobility, but, as often as not, it put him in a position of having to chase after his fees. People in positions of high power liked to make people beg. And Titian begged, urged, made compromises. His friend Aretino may have laughed heartily when he spoke of Titian's greed or when the artist was offering his princely patrons paintings and buildings materials from his timber yard in one and the same breath. But Titian was acting as a perspicacious family man who wanted to ensure that his loved ones were well cared for. If gold appealed to him as it did to Midas, then it was certainly not because of the vice of *luxuria*. What does it tell us that some patrons accused him of being unbearably slow? While it was true on occasion, as often as not it was simply a cliché. It tells us little about the artist Titian, but speaks volumes about his high-ranking clientele who were unabashed in their insistence on preferential treatment – even in their dealings with a painter so sought-after and generally regarded as 'honest'.

Saint Sebastian (detail), 1570s

This canvas, more than two metres high, is now in St Petersburg. It is Titian's last portrayal of the figure of St Sebastian. The saint, pierced by five arrows, stands amid an unfathomable flurry of sketchily blurred colours. His body shows no sign of pain. The saint appears abandoned to his fate, in existential solitude – not even the figure of an archer is to be seen – while at the same time asserting his integrity in the midst of nihilistic chaos. Sebastian lifts his searching gaze upwards, appealing for heavenly succour. We do not know, nor do we see, whether there will be any response.

Why did La Serenessima, a city embroiled in long and bitter wars against the Hapsburgs, put up with Titian's close relationship with Charles V? Presumably because Titian consistently kept out of all political matters and perhaps also because Venice did not want to lose him to the Emperor completely – just as Titian himself never gave up his rights as a Venetian citizen to ensure that he would never be fully reliant on his courtly patrons.

What does it tell us when Aretino makes a rather facetious remark about Titian flattering women without becoming erotically intimate with them – what does this tell us in view of the paintings that visualise eroticism and sexuality with almost unparalleled existential drama?

What does it tell us when Titian is accused of being an 'unintellectual' artist? In this particular aspect, enough is known about his biography to indicate that this statement is false. Yet here again, it is his works, rather than his life, that tell us of his depth – though they do not dazzle with superficial academic rhetoric, but with painterly beauty. The paintings tell of something more important still. They tell of an artist whose quest is not for painted language, but for the language of painting – a very modern quest indeed.

The lives of great artists invariably have to be freed from the aura of an unthinking cult of genius and the morass of historical gossip. The artist's life has to be understood as the mirror of the age. Titian's biography is just such a mirror – one in which the courtly world of the High and Late Renaissance are reflected with all their mores and aporia. But Titian's works are never pure reflections. They are images that interpret the world and all that interested the painter. For this reason, what he did not portray is just as important as what he did portray. For instance, he did not create light-hearted superficial décor for the villas of Venice, nor country-house frescos in which nature and myth meld dreamily and whose beauty is only skin deep. Even in his mythologies, Titian invariably portrays life in all its contrasts and richness.

Titian took his place in the hall of fame of European art within his own lifetime and the opinion of his contemporaries has been confirmed by every generation since. Not only Italian writers, but also the two great seventeenth-century art writers of Northern Europe, the Dutch Karel van Mander and the German Joachim von Sandrart, praised Titian above all for his landscapes and his woodcuts – two fields in which the Venetians had been largely inspired by German and Netherlandish art.

From here on, it was to be above all his fellow artists who admired his achievements and did so without envy. In the Baroque era, Flemish and Dutch painters such as van Dyck, Rubens, Rembrandt and most notably the Spanish painter Velázquez considered him the unsurpassed sorcerer of colour. In the eighteenth century, the English artist and academy director Joshua Reynolds is said to have scraped down a painting by Titian that he himself owned, layer by layer, in order to discover the secret of his painterly technique. In the nineteenth century, Delacroix wrote of Titian as one might describe a good

wine: "If one were to live a hundred and twenty years, one would still prefer Titian above all others. ... he is the least mannered and thus the most versatile of all painters. ... Titian never flaunts his talent; on the contrary, he despises all that does not lead to a more lifelike expression of his idea." Heinrich Heine in 1832 saw Titian in a different light than the one that Mark Twain and Thomas Bernhard wanted to see – not as the servant of princes, but as an enlightened revolutionary from whose hand not one single brushstroke was ever perverted to a social falsehood – and declared the flanks of a Titian Venus to be a far more powerful declaration of Protestantism than Luther's 95 theses. Current art history occasionally succumbs to the temptation of treating Titian, the late Titian, as an Abstract Expressionist or an avant-garde Informel artist *avant la lettre*.

The historical reality surrounding Titian is more accurately echoed in the following: in 1620, Palma the Younger, who had worked in Titian's studio for a time and who had gone on to carve out one of the most successful careers of any Venetian artist, had his future memorial installed over the sacristy door in SS. Giovanni e Paolo. It shows his own bust on the right and that of his great uncle, the painter Palma the Elder, on the left. Between them, reverentially elevated above them and presented by two putti with personifications of Fama announcing the fame of the three master artists, is the bust of Titian. Titian is the supreme artist of all Venetian painters.

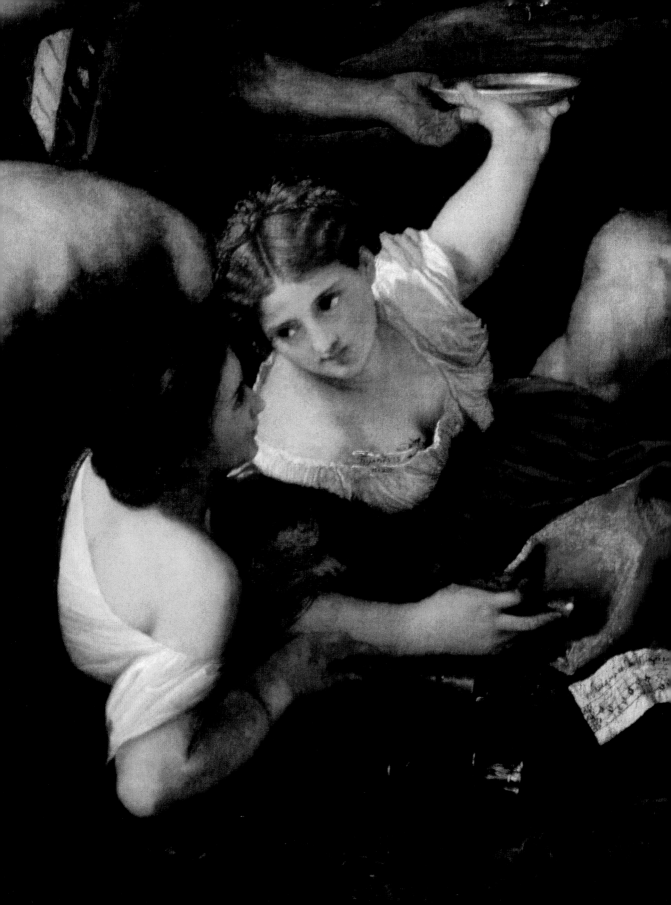

Biography and List of Works

Tiziano Vecellio was born in Pieve di Cadore (Friuli), probably some time between **1488** and **1490**. This is reported by Lodovico Dolce in 1557 and seems more plausible than the artist's own claim, in a letter to Philip II on 1 August 1571, that he was born around 1476/77. Less likely still is the date recorded in the San Canciano registry of deaths, which lists his birth year as 1473. Titian's father Gregorio di Conte Vecellio was a soldier, a respected councillor and a timber merchant in Pieve di Cadore. Titian's mother Lucia bore five children: Francesco, Tiziano, Orsola (Orsa), Caterina and Dorotea.

If we accept the biographical data recorded by Dolce, Titian is nine years old when he and his brother Francesco, about two years older than him, arrive in Venice around **1497/99** to stay with an uncle who will encourage his artistic talent. In Venice, Titian was apprentice to the mosaic artist and painter Sebastiano Zuccato († 1527), then to Gentile Bellini (c. 1430–1507) and finally to the latter's brother Giovanni Bellini (1431/36–1516), the pre-eminent artist in Venice at the time.

In **1508** Titian begins work on the outdoor frescoes of the Fondaco dei Tedeschi, which had been rebuilt following a devastating fire on 28 January 1505. The frescos are probably completed in **1509**. Most of the wall paintings, of which only some fragments now survive, are painted by Giorgione (1477/78–1510), with whom Titian collaborates closely.

1494 Charles VIII of France invades Italy, marking the beginning of the Italian Wars in which France and the Hapsburgs vie for control of the Appenine peninsula. The Medici are expelled from Florence, where they had held sway since 1434 and to which they will return in 1512. The Dominican friar Girolamo Savonarola establishes a theocratic regime in Florence and orders the destruction of many works of art.
The French historian Philippe de Commynes describes Venice as the most beautiful and glorious city in the western world, putting all else in its shadow.

1495 Venice forms an allegiance with the Pope, the Duke of Milan and the Emperor against France.
Syphilis spreads throughout Europe from French occupied Naples.

1497 Leonardo da Vinci finishes his fresco of the *Last Supper* in the refectory of S. Maria delle Grazie in Milan.

1498 Vasco da Gama reaches the coast of India by sea.
Savonarola is burned on the Piazza della Signoria in Florence.
Albrecht Dürer publishes his famous apocalyptic series of woodcuts.

1499 Venice forms an allegiance with France.
The French conquer Milan.
Turkish troops invade Friuli through the Balkans.

The earliest official document recording Titian's name is dated 1 December **1510**. In it, Nicola da Strata, acting on behalf of the Sculola del Santo, commissions the painter, whom he had visited in Venice, to paint three frescos for the chapter room (*scoletta*) of the brotherhood of St Anthony in Padua. Titian begins work on scenes from the life of Saint Anthony on 23 April **1511** and receives his final payment for these on 2 December of the same year. It is probably also in **1510** that Titian reworks and completes the Dresden *Venus* by Giorgione. The *Concert Champêtre* is also painted around this time, possibly by Titian himself.

In **1513** Cardinal Pietro Bembo (1470–1547), who was born in Venice, summons Titian to Rome on behalf of the newly elected Pope Leo X. Instead of accepting the papal invitation, Titian writes to the Venetian Council of Ten on 31 May 1513 offering his services and expressing his willingness to begin work on a large battle scene for the Sala del Maggior Consiglio in the Doge's Palace. He requests payment in the form of a lucrative state pension (the *sensaria* of the Fondaco dei Tedeschi) and funds from the Salt Office to employ two assistants. In May of the same year, his proposal is accepted. 1513 is also the year in which Titian establishes a modest work-shop in the area of San Samuele. Two assistants are known to have worked there: Antonio Buxei and Ludovico di Giovanni – the latter a former assistant of Giovanni Bellini.

On 20 March **1514**, under pressure from a number of envious painters, one of whom was prob-ably Giovanni Bellini, the Council of Ten rescinds its 1513 conces-sion, only to commission Titian once again in November to paint the battle scene in the Doge's palace.

In **1515–16** Titian works on his magnificent portrayal of *Sacred and Profane Love*.

1500 Charles, the future Emperor, is born in Ghent. The Turks conquer almost all Venetian holdings in Greece. Leonardo da Vinci visits Venice. Jacopo de' Barbari draws his monumental map of Venice, published by Anton Kolb in Nuremberg.

1502 The papal fleet under Jacopo Pesaro and the Venetian fleet under Benedetto Pesaro defeat the Turks at the Battle of Santa Maura. First (unofficial) publication in Italy of Jacopo Sannazaro's bucolic poem *Arcadia*, written about 1480, which is said to have inspired the painting *Con-cert Champêtre* (Paris, Louvre) of about 1510, variously attributed to either Giorgione or Titian. Erasmus of Rotterdam (who spent some time in Venice with Aldus Manutius, the pre-eminent publisher of the day) publishes his controversial *Enchiridion militis christiani*.

1504 The first of several anti-luxury laws is passed in Venice, directed primarily against women's ostentatious clothing and jewellery. Giorgione paints his *Castelfranco Madonna*.

1505 Giovanni Bellini completes his San Zaccaria altarpiece. The Fondaco dei Tedeschi is destroyed by fire in January. In Rome, Michelangelo designs the funerary monument for Pope Julius II.

1506 In Rome, construction of the new St Peter's begins. Also in Rome, the discovery of the late classical *Laocoon* sculpture causes a sensation. It will con-tinue to inspire countless artists over centuries to come.

1508 Conte Vecellio, Titian's grandfather, leads Venetian troops to victory over the forces of Emperor Maximilian I at Cadore. On 10 December Maximilian forms an alliance with France, Spain and the Pope against Venice in the League of Cambrai.

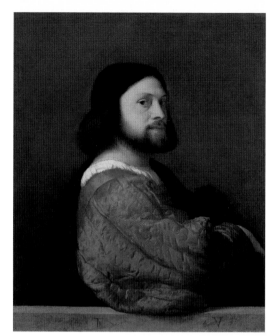

Ariosto, *c.* 1510

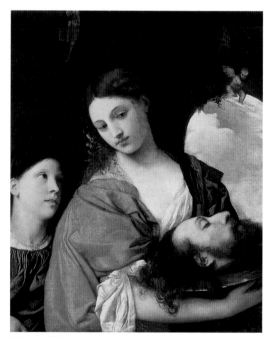

Salome, 1515

Madonna with Child, before 1507–08

Three Seated Figures Reading, 1510

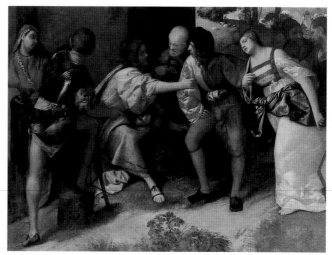

Daniel and Susanna (Christ and the Adultress), *c.* 1509

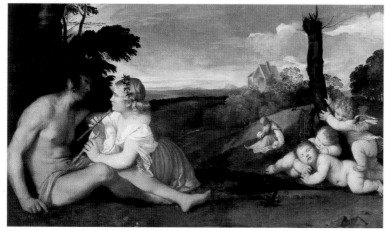

The Three Ages of Man (Daphnis and Chloë), *c.* 1511

1516 marks the beginning of Titian's contacts with the court of Ferrara. From 31 January to 22 March he and two assistants visit Alfonso I d'Este to plan the decoration of the alabaster room for which Giovanni Bellini had painted the *Feast of the Gods* in **1514**. The Ferrara artist Dosso Dossi (*c.* 1490–1542) is also involved in the project. Alfonso had approached Raphael (1483–1520) and Fra Bartolomeo (1472–1517) in connection with this project, but nothing came of this due to their early deaths. In **1516** the prior of the Franciscan order in Venice commissions Titian to paint one of his finest altarpieces, the *Assumption of the Virgin* that graces the high altar of the church of S. Maria Gloriosa dei Frari.

In **1517** Titian is once again granted a *sensaria*, a guaranteed state pension, that produced an annual income of 100 ducats, as well as a promise of twenty-five ducats for each official portrait of a newly elected Doge painted by him for the Sala del Maggior Consiglio.

On 19 May **1518** the *Assumption of the Virgin* is unveiled in the Frari church. Titian is now working on the first painting for the alabaster room in Ferrara: the *Feast of Venus,* which he delivers in person the following year.

On 24 April **1519** Titian is commissioned by Jacopo Pesaro, the Bishop of Paphos, to paint an altarpiece for the Frari church. The *Madonna with Saints and Members of the Pesaro Family* is completed in 1526.

1520 is a year of two major altarpieces: one commissioned by Alvise Gozzi for San Francesco in Ancona and another commissioned by the papal legate Altobello Averoldi for SS Nazaro e Celso in Brescia (final payment **1522**). At the same time, Titian is also working on his *Bacchus and Ariadne* and his *The Andrians (Bacchanalia).*

Titian travels extensively in the following years. In **1521** he is in Brescia, Vicenza and probably Conegliano.

Giorgione begins his *Venus* (now in Dresden). At the same time, he is working (from 1507) on the frescoes for the façade of the Fondaco dei Tedeschi. In Rome, Michelangelo begins the painting the Sistine Chapel ceiling, which he completes in 1512.

1509 The Dominican monk Las Casas initiates the Atlantic slave trade, shipping African slaves to the Spanish colonies to supplement the indentured labour of the indigenous American population.
Venice regains control of Padua from the imperial forces.
Raphael begins his frescos for the Stanze della Segnatura in the Vatican. In the following years, with his workshop, he creates monumental fresco cycles in other rooms in the Vatican Palace.

1510 Luther travels to Rome. There is an outbreak of the plague in Venice (further major epidemics occurred in 1528/29, 1552, 1556/57, 1572 and 1575/76).

1513 Leo X becomes Pope following the death of Julius II. Raphael completes his *Sistine Madonna* (now in Dresden). Giovanni Bellini creates his altarpeice for San Giovanni Crisostomo in Venice.

1514 The Rialto district in Venice is ravaged by fire.
Dosso Dossi, who would later be influenced by Titian, starts work at the Este court in Ferrara. Giovanni Bellini signs and dates his *Feast of the Gods* for Alfonso I d'Este.

1517 Peace is concluded between Venice and Emperor Maximilian on 7 January.
Martin Luther nails his ninety-five theses to the church door at Wittenberg, heralding the start of the Reformation.

1520 Charles V is crowned emperor after the death of Maximilian in 1519.
Michelangelo is commissioned to create the funerary sculptures for the Medici Chapel in Florence. Pordenone creates the frescos in the Malchiostro Chapel in the Cathedral of Treviso.

Virgin with Child and Saint Catherine and Saint George, *c.* 1516

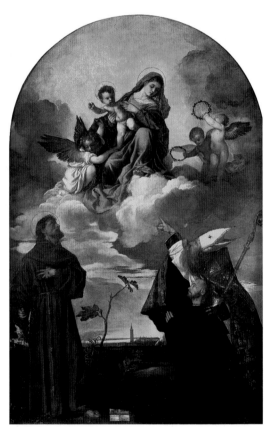

Virgin and Child in Glory with Saints Francis and Alvise and the Patron, so-called **Pala Gozzi,** 1520

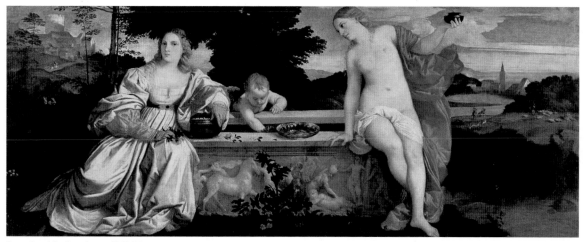

Sacred and Profane Love, 1515/16

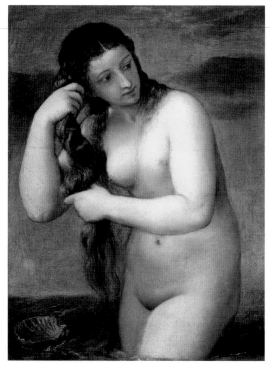

Venus Anadyomene, *c.* 1518/19

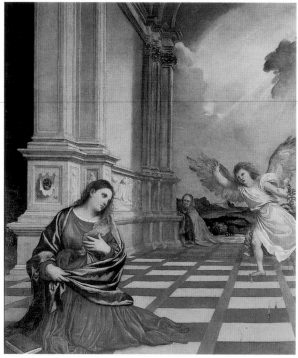

Annunciation, *c.* 1520

In **1523** he is again in Ferrara to supervise the hanging of the last two mythology paintings in the alabaster room. Titian's first contact with Federico Gonzago, Marchese de Mantua, is documented in this year, though this acquaintance will be built up over the following years. During the same period, in Mantua, Titian meets Pietro Aretino (1492–1556). Titian is working on frescos in the Doge's Palace at this time. He is back in Ferrara from November **1524** until the beginning of the following year.

In **1525** Titian marries his housekeeper Cecilia, with whom he already has two sons, Pomponio and Orazio. His pupil Girolamo Dente acts as their witness. Titian's marriage is prompted by his wish to legalise their relationship before the death of Cecilia, who is seriously ill. However, the necessary documents seem to have been missing, for his marital status has to be reconfirmed by the Magistrato dell'Esaminador in October **1550**. At that time Titian is in Augsburg at the imperial court and clearly wishes to secure the status of his children.

Following the Sack of Rome, Aretino moves to Venice in **1527**. What has previously been a fleeting acquaintance with Titian develops into a lifelong friendship. In the same year, Aretino offers Titian's portrait of him, as well as another portrait, to Federico Gonzaga.

In **1528** Titian is in Ferrara again. A committee entrusted with choosing between Titian, Palma il Vecchio (*c.* 1480–1528) and Pordenone (1483–1539) for the *Martyrdom of Saint Peter* altarpiece in SS Giovanni e Paolo in Venice, decides to commission Titian. The painting, completed in **1530** (destroyed by fire in 1867), causes a sensation.

In March **1529** Titian is at the court of Mantua, before continuing to Ferrara (where he had already spent the first two months of the year) and 'modernises' Bellini's *Feast of the Gods*. In October, through the mediation of Federico Gonzaga, Titian is presented to the Holy Roman Emperor Charles V for the first time, in Parma.

1523 Venice and Charles V form an alliance against France.

1525 Charles V defeats and captures François I of France at the Battle of Pavia, ending French supremacy in Italy and securing Spanish rule.

1527 Paracelsus presents his new medical concepts at the University of Basle, unequivocally opposing traditional medical practice.
The Sack of Rome by imperial mercenaries is generally regarded as coinciding with the end of the Renaissance and the beginning of Mannerism.
In April, Pietro Aretino moves to Venice.

1528 Venice forms an alliance with François I of France against Charles V.
Baldassare Castiglione's *Il Cortegiano* (The Book of the Courtier) is published.
Sebastiano Serlio's architectural theories are influential in Venice even before his treatise is published in 1537.

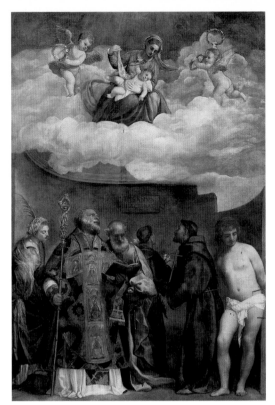

Virgin and Child in Glory with Saints Catherine, Nicholas, Peter, Antonius from Padua, Francis and Sabastian, *c.* 1521/22

Portrait of Laura de Dianti, *c.*1523

Portrait of Isabella d'Este, 1534–36

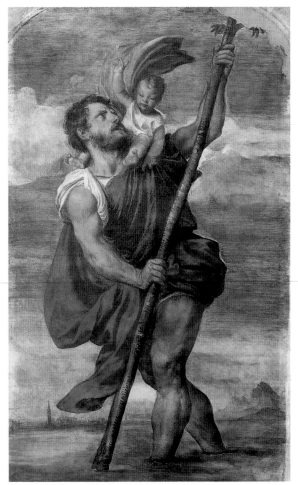

Saint Christopher, *c.* 1523

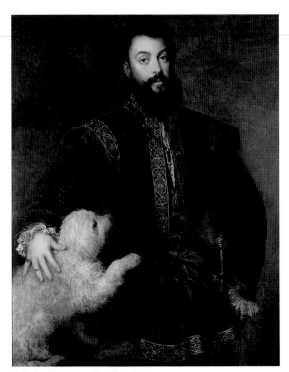

Federico Gonzaga with a Dog, 1529

In **1530** Titian's wife Cecilia dies immediately after giving birth to their daughter Lavinia. From then on, Titian's sister Orsa takes on the duties of housekeeper and cares for the children. This is probably the year in which Titian paints his first portrait of Charles V.

One year later, Titian is working on several paintings for the Duke of Mantua, including a *Saint Jerome* and a *Christ and the Woman Taken in Adultery*. In **1531** he finally secures the benefice of Medole for his son Pomponio, in the hope that this will help him to pursue a brilliant career in the church – though this never materialises. In September of the same year Titian leaves his workshop in the San Samuele area and rents a house with studio in the Biri Grande in the parish of San Canciano, close to where Aretino lives. Titian will spend the rest of his life in this house.

In **1532** the architect Sebastiano Serlio introduces Titian to Francesco Maria I della Rovere, Duke of Urbino, who is also Captain General of the Republic of Venice. Titian immediately produces several paintings for him.

In January **1533** Titian paints a (now lost) portrait of Emperor Charles V in Bologna. In addition to a princely fee for his work, Titian is elevated to the nobility on 10 May, becoming Count of the Lateran Palace, of the Aulic Council and the Consistory, Count Palatine and Knight of the Golden Spur, with appurtenant imperial rights and honours for four generations of his family. Titian paints further works for the Emperor. He declines an invitation to Madrid, as reported by the Spanish envoys to Venice, Rodrigo Niño and Lope de Soria – a refusal he is to repeat in the coming years.

In **1534** Titian's father Gregorio Vecellio dies.

1530 Coronation of Emperor Charles V in Bologna. Venice appoints Pietro Bembo the official chronicler of the Republic. In the 1530s more than five laws are passed in Venice concerning the wearing of luxurious jewellery. In 1533 it is decreed that women may wear only one simple string of pearls worth 150 ducats around their necks; pearls in the hair are forbidden. Few women observed the law – even Titian's female sitters are often shown wearing pearls.

1531 The appearance of Halley's Comet triggers superstitious anxieties and apocalyptic fears throughout Europe. In Venice, the young Lorenzo Venier, of one of the city's most respected families, publishes his poem *Il Trentuno della Zaffeta*, glorifying the rape of the fourteen-year-old courtesan Angela del Moro, an acquaintance of Titian's, by a group of eighty low-life thugs (a *trentuno*, i.e. thirty-one, refers to a gang rape) and defending their actions as a 'justified' response to her having allegedly insulted a noble client. The poem appears to be based on fact. The author even points out gleefully that the courtesan has been infected with deadly syphilis in the incident. Violence against courtesans was widespread in Venice. At the same time, they were hailed as delightful companions and as intellectually and culturally sophisticated servants of love.

1532 Macchiavelli's *Il Principe* is published.

1534 Henry VIII of England breaks with the Church of Rome. The Jesuit order is founded. Michelangelo settles permanently in Rome.

Virgin and Child with Saint John the Baptist and Saint Catherine, *c.* 1530

Study for Saint Bernhardin, *c.* 1531

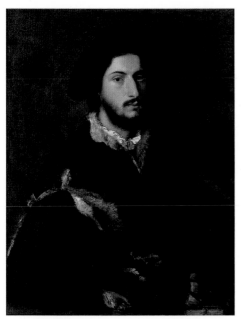

Portrait of a Gentleman (Tomaso Mosti or Vincenzo Mosti), *c.* 1530

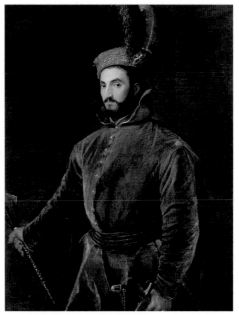

Cardinal Ippolito de' Medici, 1532/33

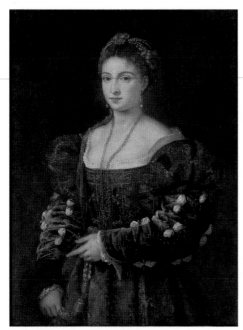

Portrait of a Lady (La Bella), 1536

Saint Jerome, 1531

On 1 April **1535** Titian, together with Sebastiano Serlio and Fortunio Spira, is commissioned to conduct a survey of the proportions of the church of San Francesco della Vigna in Venice.

In **1536** Titian begins work on his portrait of *Francesco Maria della Rovere* and probably also on the portrait of *Eleonora Gonzaga* – both paintings are completed the following year and delivered to Pesaro in **1538**. Federico Gonzaga commissions Titian to paint a cycle of twelve images of Ancient Roman emperors for a room in his palazzo in Mantua. Four of the portraits arrive in Mantua in **1537**. Charles V, having met Titian in 1536 in Asti, instructs the viceroy of Naples, Don Pedro di Toledo, to provide his 'first painter' with a generous supply of grain as an annual allowance (Titian never actually receives it).

In **1538** Titian completes his battle scene for the Sala del Maggior Consiglio in the Doge's palace. The Serenissma continues to favour Pordenone until his death in 1539, rescinding the *sensaria* for the Fondaco dei Tedeschi granted to Titian in **1517** (but reinstated on 23 June **1539**). Titian paints the *Venus of Urbino* for the new Duke of Urbino, Guidobaldo II, and also paints a portrait of King Francois I of France, based on a medallion by Benvenuto Cellini (1500–71).

In **1539** he completes the *Presentation of the Virgin at the Temple* for the Scuola Grande di Santa Maria della Carità in Venice.

The following years are dominated by portrait painting. Emperor Charles V continues to revere Titian's artistic talents.

On 25 August **1541** the artist is granted an imperial allowance of 100 ducats.

1536 Michelangelo begins his fresco of the *Last Judgment* (completed 1541) on the altar wall of the Sistine Chapel.

1541 The Turks conquer Buda. Cartier leads a French expedition to the St Lawrence in Canada. The Papal Bull against Lutheranism is issued in Venice. Giorgio Vasari visits Venice.

John the Baptist, late 1530s(?)

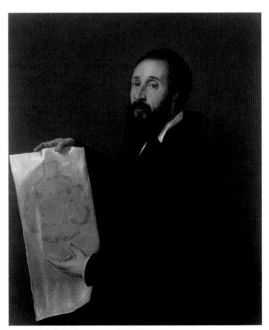

Portrait of Guilio Romano, 1536/38

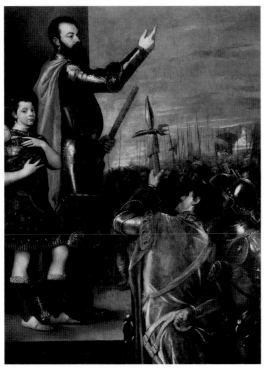

Allocuzione des Alfonso d'Avalos, 1539–41

Portrait of Francesco Maria della Rovere, 1536

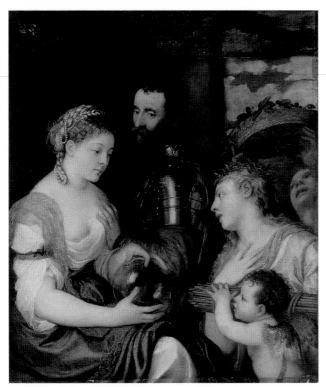

An Allegory, Perhaps of Marriage, with Vesta and Hymen as Protectors and Advisers of the Union of Venus and Mars, *c.* 1540

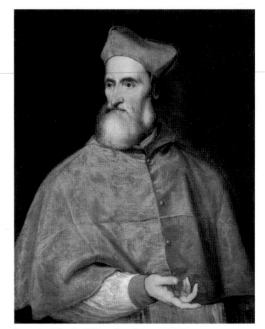

Portrait of Cardinal Pietro Bembo, *c.* 1539/40

In **1542** Titian starts work on his cycle of ceiling paintings for Santo Spirito in Isola, which he completes two years later. In **1543** he signs and dates the *Ecce Homo* (now in Vienna) and paints a portrait of Pope Paul III in Bologna. In **1544** he paints the *Danaë* for Cardinal Alessandro Farnese.

In September **1545,** after painting various portraits, including one of Pietro Aretino, Titian and his son Orazio are guests of Guidobaldo II in Pesaro and Urbino. They travel to Rome, where Titian paints portraits of the Farnese family, including the famous painting of *Pope Paul III and his Grandsons Alessandro and Ottavio Farnese*. From his base in Rome, where he regularly meets Giorgio Vasari (1511–74) and Sebastiano del Piombo (c. 1485–1547) as well as Michelangelo (1475–1564). Titian intervenes on behalf of the architect and sculptor Jacopo Sansovino (1486–1570), whom the Venetian authorities have accused of mismanaging the construction of the Libreria Marciana. In **1546** Paul III makes Titian an honorary citizen of Rome. Having offered his services in vain to Cosimo de'Medici, Grand Duke of Tuscany, Titian returns to Venice without the generous benefice he had hoped to obtain for his son Pomponio.

In **1547** Charles V summons Titian to Augsburg. The artist sets out in January **1548** accompanied by his son Orazio, his nephew Cesare and his pupil Lambert Sustris (1510/15–after 1560). Titian attends the ceremonious inauguration of the Reichstag (Imperial Diet). He paints several portraits of the nobility, most famously *Portrait of Charles V on Horseback*, which he completes between April and September of that year. Mary of Hungary also commissions a series of paintings from her brother's court painter. On the return journey, Titian stops in Innsbruck, where he begins a portrait of King Ferdinand, the brother of Charles V. Towards the end of the year, he paints his first portrait of Prince Philip, who remunerates him generously for various portraits at the beginning of the following year.

1545 Start of the Council of Trent (closed 1563).

1546 War breaks out between Charles V and the Protestant Schmalkald League in the same year as Luther dies. Michelangelo presents his first design for the dome of St Peter's.

1547 In France, Henri II succeeds Francois I.

1548 In Venice, Paolo Pino's *Dialogo della Pittura* is published. During Titian's absence Tintoretto completes the *Miracle of St Mark* for the Scuola Grande di San Marco within a few months, earning great praise from Pietro Aretino.

1549 Farnese Pope Paul III dies and is succeeded by Julius III. Venice suffers a great famine. Andrea Palladio begins work on the Pallazo della Regione, known as the Basilica Palladiana.

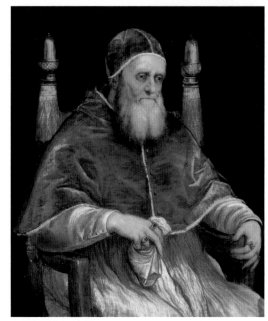

Portrait of Pope Julius II, *c.* 1550

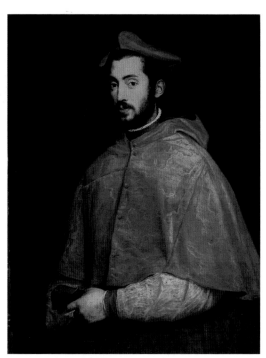

Portrait of Alessandro Farnese, *c.* 1545/46

Self-Portrait, *c.* 1550/62

Saint John the Evangelist on Patmos, *c.* 1547

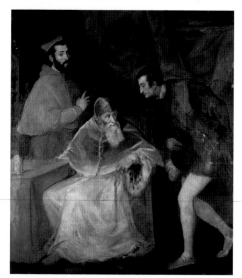

Pope Paul III and his Grandsons Alessandro and Ottavio Farnese, 1546

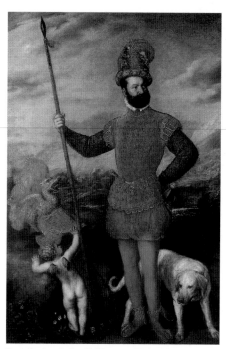

Portrait of an Italian Nobleman with Cupid and a Dog, *c.* 1550

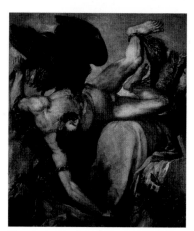

Tityus, completed 1549

1550 finds Titian in Augsburg again. Before returning to Venice in **1551**, he petitions the Emperor, who has commissioned the *Gloria* painting, to give his friend Aretino the office of cardinal.

1552 marks the beginning of Titian's correspondence with Philip II. Many of the letters are about (outstanding) payments. In **1553** Titian begins work on the first of his *poesie* for Philip. Including *Venus and Adonis* and a *Danaë*.

In **1555** Titian's daughter Lavinia marries Cornelio Sarcinelli of Serravalle. Girolamo Dente, one of Titian's assistants, acts as their witness.

In **1557**, together with Jacopo Sansovino, Titian is a member of a jury called to evaluate the quality of the ceiling paintings in the Libreria Marciana, created by artists including Paolo Veronese (1528–88).

In **1559** Titian's older brother Francesco dies. The altarpiece of the *Martyrdom of Saint Lawrence*, begun in **1548**, is installed in the Chiesa dei Gesuiti in Venice. On 12 June 1559 Titian writes to Philip II about the (mysterious) assassination attempt by the imperial medallist Leone Leoni (*c.* 1509–90) on his son Orazio. In the autumn, he tells Philip he is undertaking a series of paintings, including two different versions of *Diana and Actaeon*, a *Diana and Callisto*, and is working on the *Rape of Europa*.

In **1561** Titian's daughter Lavinia dies.

1550 First edition of Vasari's *Lives of the Artists*. At Tivoli, near Rome, Cardinal Ippolito d'Este creates the park and fountains of the Villa d'Este.

1553 In Brussels, Emperor Charles V is distraught to hear rumours of Titian's death and instructs his Venetian envoy Francesco Vargas to investigate.

1555 The Peace of Augsburg secures religious freedom for the estates, but not for the common subjects. In Geneva, the Calvinist Reformation is victorious.
Nostradamus publishes his astrological prophecies.
In Venice, Paolo Veronese begins work on the decoration of the church of San Sebastiano, continuing until 1570.

1556 Charles V abdicates and retires to Yuste Monastery in Spain. His brother Ferdinand takes the imperial throne. His son Philip, as King of Spain, rules the New World colonies and the Hapsburg territories in Italy.
Death of Pietro Aretino.

1557 Lodovico Dolce's *Dialogo della pittura* is published.

1558 Spanish troops occupy the Netherlands. Charles V dies at Yuste Monastery.

1561 Mary Stuart returns to Scotland and lays claim to the throne of England.
In Rome, Palestrina becomes choirmaster of various churches, culminating in his appointment to St Peter's. In Venice, Tintoretto paints the *Wedding at Cana*.

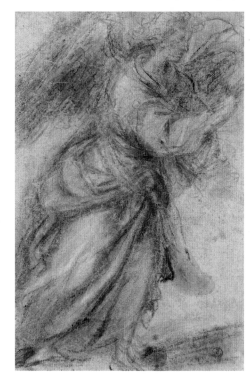

The Archangel Gabriel, *c.* 1557

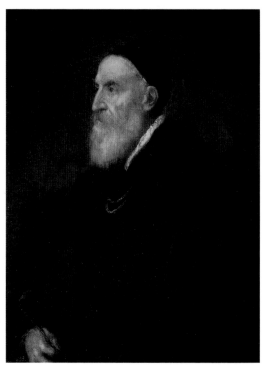

Self-Portrait, *c.* 1562

Christ on the Cross, *c.* 1555

Salome, 1560

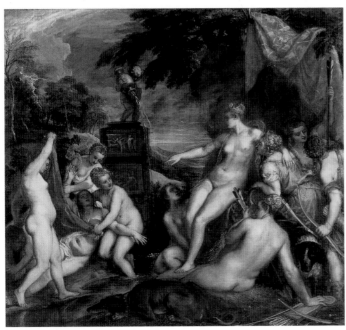

Diana and Callisto, 1556–59

Titian's creative powers are un-diminished. In **1564** he accepts a commission from Philip II for an altarpiece for El Escorial depicting the *Martyrdom of Saint Lawrence,* which is delivered to Spain in **1567**. In October 1564, in Brescia, he signs a contract for three ceiling paintings in the Palazzo Pubblico of Brescia (destroyed by fire in 1575). In **1565** he has members of his workshop begin work on frescos in Pieve di Cadore.

As there is no art academy in Venice, Titian, the architect Andrea Palladio (1508–80), Jacopo Tintoretto (1519–94) and other Venetian artists successfully apply in **1566** for membership of the Accademia del Disegno in Florence.

In late **1570** or early **1571** Titian sends Philip II a painting entitled *Rape of Lucretia* (*Tarquin and Lucretia*) — presumably the one now in the Fitzwilliam Museum in Cambridge. Around 1570 he creates such magnificent late works as *Christ Crowned with Thorns* (now in Munich) and the *Flaying of Marsyas.*

From **1573** he is working on the great allegory *Religion Succoured by Spain*, glorifying the victory over the Turks at the Battle of Lepanto (sent to Spain in **1575**). The *Allegory of the Battle of Lepanto* is created between 1571 and 1575 (Prado, Madrid).

1562 Start of the Huguenot Wars of France.

1563 Philip II commissions the construction of the El Escorial. Paolo Veronese completes the *Wedding at Cana* for the refectory of the Benedictine monastery of San Giorgio Maggiore in Venice.

1564 Birth of William Shakespeare and Galileo Galilei. Death of Michelangelo. Tintoretto begins his twenty-year project of decorating the Scuola Grande di San Rocco in Venice.

1565 Revolt of the Spanish Netherlands under William of Orange and Count Egmont.

1566 Andrea Palladio begins work on the church of San Giorgio Maggiore in Venice.

1567 Calvinist iconoclasm in the Netherlands. London Stock Exchange founded. Domenico Theotokopulos, known as El Greco, settles temporarily in Venice where he is presumed to have worked in Titian's workshop.

1568 The second edition of Vasari's *Lives of the Artists* is published.

1570 The Turks conquer Cyprus, previously held by Venice. Andrea Palladio publishes his *Quattro libri di Architettura* in Venice. El Greco moves to Rome.

1571 Italian and Spanish ships led by Don Juan d'Austria, an illegitimate son of Charles V, win the Battle of Lepanto, ending Turkish hegemony in the Mediterranean. In France, Huguenots are massacred in the so-called Saint Bartholomew's Day Massacre from 22–23 August.

Carrying of the Cross, *c.* 1566

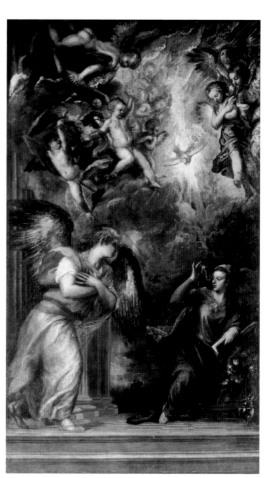

Annunciation, completed 1563–66

Rape of Lucretia (Tarquin and Lucretia), *c.* 1570

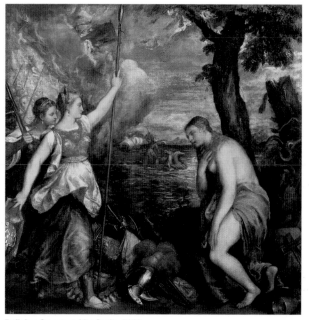

Religion Succoured by Spain, 1571

Portrait of Jacopo Strada, 1567/68

Venus Blindfolding Cupid, 1565

In July **1574** Henri de Valois, returning from Poland to France where he is to be crowned Henri III, visits Titian in his studio in Venice.

In the final years of his life, Titian works primarily for Philip II, though he constantly has to remind him of outstanding fees, as in his very last letter of 27 February **1576**.

On 27 August **1576** Titian dies at his home in the Biri Grande – probably, though this is not definitively proven, of the plague. He is ceremoniously laid to rest in S. Maria Gloriosa dei Frari. At about the same time, his son Orazio also dies. The abandoned house, full of precious objects and paintings, is broken into. The *Pietà* is bequeathed to Palma il Giovane (*c.* 1548–1628), the grand-nephew of Jacopo Palma il Vecchios.

On 27 October **1581** Titian's house, probably still containing a number of paintings by the master himself, is sold to Cristoforo Barbarigo by his surviving son Pomponio.

1574 On 11 May a huge fire in the Sala del Collegio and the Sala del Senato in the Doge's Palace in Venice destroys many paintings, including some by Titian.

1575 A terrible plague sweeps through Venice from 25 June.

1576 El Greco leaves Italy for Toledo, Spain.

1577 Another major fire in the Doge's Palace destroys famous paintings by Gentile and Giovanni Bellini, Alvise Vivarini, Vittore Carpaccio, Paolo Veronese, Jacopo Tintoretto – and Titian.

Saint Sebastian, 1570s

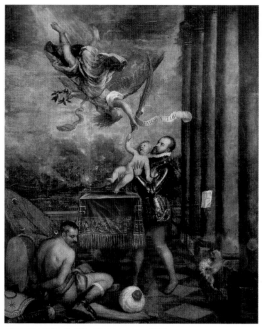

Allegory of the Battle of Lepanto, c. 1575

Saint Jerome in the Wilderness, *c.* 1575

Doge Antonio Grimani Kneeling before the Faith, *c.* 1566/74

List of Works Illustrated

This list includes works by Titian only.
Details of works by other artists have been included
next to the works in the main text.

Page 2
Woman with a Fruit Bowl, 1555, oil on canvas,
102 x 82 cm, Gemäldegalerie, Staatliche Museen
zu Berlin

Page 4
Venus Blindfolding Cupid (detail), 1565

Page 6
Man with a Glove (detail), *c.* 1520

Page 8
The Andrians (Bacchanalia)(detail), 1523

Page 10
Man with a Glove (detail), *c.* 1520

Page 13
Vendramin Family (detail), *c.* 1543–47

Page 15
Venus at her Mirror, (detail), *c.* 1550/60

Page 16
Bacchus and Ariadne (detail), *c.* 1520–23

Page 19
Portrait of a Lady (La Bella) (detail), 1536

Page 20
Self-Portrait (detail), *c.* 1550/62

Page 23
Portrait of Paul III, 1543, oil on canvas, 106 x 85 cm,
Museo e Gallerie Nazionali di Capodimonte, Naples

Page 24, 26/27
Madonna of the Rabbit, *c.* 1529, oil on canvas,
71 x 87 cm, Musée du Louvre, Paris

Page 28
The Concert, *c.* 1510/12, oil on canvas, 86.5 x
123.5 cm, Palazzo Pitti, Galleria Palatina, Florence

Pages 29/30
Pietà, 1570–76, oil on canvas, 378 x 347 cm,
Gallerie dell'Accademia, Venice

Page 32
Annunciation (detail), see p. 134

Page 34
Venus Blindfolding Cupid (detail), see p. 135

Page 35
Portrait of Doge Andrea Gritti, *c.* 1545, oil on
canvas, 133.6 x 103.2 cm, National Gallery of Art,
Samuel H. Kress Collection, Washington

Pages 36/37
Vendramin Family, *c.* 1543–47, oil on canvas,
206 x 301 cm, National Gallery, London

Page 38
Gypsy Madonna, *c.* 1510/12, oil on panel, 65.8 x
83.8 cm, Kunsthistorisches Museum, Vienna

Page 39
**Pope Alexander VI Presenting Jacopo da Pesaro to
Saint Peter**, 1503–07 or after 1508, oil on canvas,
145 x 183 cm, Antwerpen, Koninklijk Museum voor
Schone Kunsten

Judith or **Allegory of Justice**, *c.* 1508/09, fresco,
212 x 346 cm, fresco fragment of Fondaco dei
Tedeschi, Galleria Giorgio Franchetti, Ca' d'Oro,
Venice

Page 40
Giorgione and/or Titian, **Concert Champêtre**,
c. 1510, oil on canvas, 110 x 138 cm, Musée du
Louvre, Paris

Page 41
Il Bravo, *c.* 1515/20, oil on canvas, 77 x 66.5 cm,
Kunsthistorisches Museum, Vienna

Pages 42/43
Frescos of Scuola del Santo in Padua, 1511
p. 42 *left: The Miracle of the Reattached Foot*,
327 x 320 cm
p. 42 *right: The Miracle of the Jealous Husband*,
327 x 183 cm
p. 43: *The Miracle of the Newborn Child*,
320 x 315 cm

Page 44
Battle on Horse, 1537/38, white and black chalk
on paper, 35 x 25.1 cm, Staatliche Graphische
Sammlung, Munich

Rider falling off a Horse, *c.* 1537, black and white
chalk on paper, 27.4 x 26.2 cm, Ashmolean Museum,
Oxford

Study for Saint Peter, *c.* 1516, black and white
chalk on paper, 15.7 x 13.4 cm, The Trustees of
the British Museum, London

Page 45
**Saint Mark Enthroned with Saints Cosmas
and Damian, Rochus und Sebastian** (Mark Altar),
c. 1508/09, oil on panel, 218 x 149 cm,
Santa Maria della Salute, Venice

Page 46
Assumption of the Virgin, 1516–18, oil on panel,
690 x 360 cm, Santa Maria Gloriosa dei Frari, Venice

Page 47
**Madonna with Saints and Members of the Pesaro
Family**, 1519–26, oil on canvas, 478 x 266.5 cm,
Santa Maria Gloriosa dei Frari, Venice

Page 49
Presentation of the Virgin at the Temple,
1534–38, oil on canvas, 335 x 775 cm,
Galleria dell'Accademia, Venice

Page 50
Triumph of Faith (detail), *c.* 1511,
woodcut, *c.* 38.5 x 268 cm, Museo Correr,
Gabinetto di Stampe e Disegni, Venice

Pages 52/53
Sacred and Profane Love (detail), see p. 123

Page 54
Portrait of Benedetto Varchi, 1540–43, oil on canvas,
117 x 91 cm, Kunsthistorisches Museum, Vienna

Page 55
La Schiavona, *c.* 1510, oil on canvas, 117 x 97 cm,
National Gallery, London

Page 56
**Six Studies for Saint Sebastian and a Virgin and
Child**, *c.* 1520, pen and ink, 16.2 x 13.6 cm,
Gemäldegalerie, Staatliche Museen zu Berlin

Page 57
The Reserection in Brescia (Averoldi-Polyptych),
1522, oil on panel, San Nicolò, Brescia
centre: Christ Risen, 278 x 122 cm
top left: The Angel of the Annunciation,
right: The Virgin Mary, both 79 x 85 cm
*bottom left: Altobello Averoldi and the Saints
Nazarius and Celsus*;
right: Saint Sebastian, both 170 x 65 cm

Page 58
Cain and Abel, 1544, oil on canvas, 298 x 282 cm,
Santa Maria della Salute, Venice

The Sacrifice of Isaac, 1544, oil on canvas,
328 x 284.5 cm, Santa Maria della Salute, Venice

Page 59
David and Goliath, 1544, oil on canvas,
300 x 285 cm, Santa Maria della Salute, Venice

Page 60
Federico Gonzaga with a Dog (detail), see p. 125

Page 61
Giovanni Bellini and Titian, **Feast of the Gods**,
1514/29, oil on canvas, 170.2 x 188 cm,
National Gallery of Art, Widener Collection,
Washington

Page 62
Worship of Venus, 1519, oil on canvas,
172 x 175 cm, Museo del Prado, Madrid

Page 63
Bacchus and Ariadne, *c.* 1520–23, oil on canvas,
175 x 190 cm, National Gallery, London

Daniel and Susanna (Christ and the Adultress), *c.* 1509, oil on canvas, 139.2 x 181.7 cm, Art Gallery and Museum, Glasgow

The Three Ages of Man (Daphnis and Chloë), *c.* 1511, oil on canvas, 90 x 150.7 cm, National Gallery of Scotland, Edinburgh

Pages 122/123
Virgin and Child with Saint Catherine and Saint George, *c.* 1516, oil on panel, 86 x 130 cm, Museo del Prado, Madrid

Virgin and Child in Glory with Saints Francis and Alcise and the Patron, so-called Pala Gozzi, 1520, oil on panel, 312 x 215 cm, Musei Civico, Ancona

Sacred and Profane Love, 1515/16, oil on canvas, 118 x 278 cm, Galleria Borghese, Rome

Venus Anadyomene, *c.* 1518/19, oil on canvas, 75.8 x 57.6 cm, National Gallery of Scotland, Edinburgh

Annunciation, *c.* 1520, oil on panel, 210 x 176 cm, Malchiostro Chapel, Treviso Cathedral

Pages 124/125
Virgin and Child in Glory with Saints Catherine, Nicholas, Peter, Antonius from Padua, Francis and Sabastian, *c.* 1521/22, oil on panel, transferred onto canvas, 420 x 290 cm, Pinacoteca Vaticana, Rome

Portrait of Laura de Dianti, *c.* 1523, oil on canvas, 118 x 93 cm, Sammlung Heinz Kisters, Kreuzlingen

Portrait of Isabella d'Este, 1524–36, oil on canvas, 102 x 64 cm, Kunsthistorisches Museum, Vienna

Saint Christopher, *c.* 1523, fresco, 310 x 186 cm, Palazzo Ducale, Venice

Federico Gonzaga with a Dog, 1529, oil on panel, 125 x 99 cm, Museo del Prado, Madrid

Pages 126/127
Virgin and Child with Saint John the Baptist and Saint Catherine, *c.* 1530, oil on canvas, 100.6 x 142.2 cm, The Trustees of the National Gallery, London

Study for Saint Bernhardin, *c.* 1531, charcoal, white chalk on paper, 38.1 x 26.6 cm, Gabinetto Disegni e Stampe degli Uffizi, Florence

Portrait of a Gentleman (Tomaso Mosti or Vincenzo Mosti), *c.* 1530, oil on canvas, 85 x 67 cm, Palazzo Pitti, Florence

Cardinal Ippolito de'Medici, 1532/33, oil on canvas, 139 x 107 cm, Palazzo Pitti, Florence

Portrait of a Lady (La Bella), 1536, oil on canvas, 89 x 75.5 cm, Palazzo Pitti, Florence

Saint Jerome, 1531, oil on canvas, 80 x 102 cm, Musée du Louvre, Paris

Pages 128/129
John the Baptist, late 1530s, oil on canvas, 201 x 134 cm, Gallerie dell'Accademia, Venice

Portrait of Giulio Romano, 1536/38, oil on canvas, 102 x 87 cm, Municipal Collection, Mantua

Allocuzione des Alfonso d'Avalos, 1539/40, oil on canvas, 223 x 165 cm, Museo del Prado, Madrid

Portrait of Francesco Maria della Rovere, 1536, oil on canvas, 114 x 103 cm, Galleria degli Uffizi, Florence

An Allegory, Perhaps of Marriage, with Vesta and Hymen as Protectors and Advisors of the Union of Venus and Mars, *c.* 1540, oil on canvas, 100 x 107 cm, Musée du Louvre, Paris

Portrait of Cardinal Pietro Bembo, *c.* 1539/40, oil on canvas, 94.5 x 76.5 cm, National Gallery of Art, Washington

Pages 130/131
Portrait of Pope Julius II, *c.* 1550, oil on panel, 99 x 82.5 cm, Palazzo Pitti, Florence

Portrait of Alessandro Farnese, *c.* 1545/46, oil on canvas, 99 x 79 cm, Museo e Gallerie Nazionali di Capodimonte, Naples

Self-Portrait, *c.* 1550/62, oil on canvas, 96 x 75 cm, Gemäldegalerie, Staatliche Museen zu Berlin, Berlin

Saint John the Evangelist on Patmos, *c.* 1547, oil on canvas, 237.6 x 263 cm, National Gallery of Art, Washington

Pope Paul III and his Grandsons Alessandro and Ottavio Farnese, 1546, oil on canvas, 210 x 174 cm, Museo e Gallerie Nazionali di Capodimonte, Naples

Portrait of an Italian Nobleman with Cupid and a Dog, *c.* 1550, oil on canvas, 229 x 155.5 cm, Staatliche Kunstsammlungen, Gemäldegalerie alte Meister, Kassel

Tityus, 1549, oil on canvas, 253 x 217 cm, Museo del Prado, Madrid

Pages 132/133
The Archangel Gabriel, *c.* 1557, charcoal, white chalk on paper, 42.2 x 27.9 cm, Gabinetto Disegni e Stampe degli Uffizi, Florence

Self-Portrait, *c.* 1562, oil on canvas, 86 x 69 cm, Museo del Prado, Madrid

Christ on the Cross, *c.* 1555, oil on canvas, 214 x 109 cm, El Escorial

Salome, 1560, oil on canvas, 87 x 80 cm, Museo del Prado, Madrid

Diana and Callisto, 1556–59, oil on canvas, 188 x 206 cm, National Gallery of Scotland, Edinburgh

Pages 134/135
Carrying of the Cross, *c.* 1566, oil on canvas, 96 x 80 cm, State Hermitage Museum, St Petersburg

Annunciation, *c.* 1563/66, oil on canvas, 403 x 235 cm, Chiesa di San Salvador, Venice

Rape of Lucretia (Tarquin and Lucretia), *c.* 1570, oil on canvas, 188.9 x 145.4 cm, Fitzwilliam Museum, Cambridge

Religion Succoured by Spain, 1571, oil on canvas, 168 x 168 cm, Museo del Prado, Madrid

Portrait of Jacopo Strada, 1567/68, oil on canvas, 195 x 125 cm, Kunsthistorisches Museum, Vienna

Venus Blindfolding Cupid, 1565, oil on canvas, 118 x 185 cm, Galleria Borghese, Rome

Pages 136/137
Saint Sebastian, 1570s, oil on canvas, 210 x 115.5 cm, State Hermitage Museum, St Petersburg

Allegory of the Battle of Lepanto, *c.* 1575, oil on canvas, 325 x 274 cm, Museo del Prado, Madrid

Saint Jerome in the Wilderness, *c.* 1575, oil on canvas, 184 x 177 cm, Real Monasterio, El Escorial

Doge Antonio Grimani Kneeling before the Faith, *c.* 1566/74, oil on canvas, 373 x 496 cm, Palazzo Ducale, Venice

Selected Bibliography

The bibliography concentrates on major publications, most of them recent. Studies of individual works or specific aspects of Titian's œuvre are included if they also address wider issues. Publications marked * may be regarded as authoritative or detailed general studies.

EXHIBITION CATALOGUES

Dreyer, Peter, *Tizian und sein Kreis. 50 venezianische Holzschnitte aus dem Berliner Kupferstichkabinett, Staatliche Museen Preußischer Kulturbesitz*, Berlin 1972

The Genius of Venice 1500–1600, Jane Martineau and Charles Hope (eds.), London 1983

Wettstreit der Künste, Munich/Cologne 2002

Le Siècle de Titien. L'âge d'or de la peinture à Venise, Richard Peduzzi (ed.), Paris 1993

Der Glanz der Farnese. Kunst und Sammelleidenschaft in der Renaissance, Milan/Munich 1995

Tiziano. Amor Sacro e Amor Profano, Claudio Strinati (ed.), Milan 1995

Giorgione. Mythos und Enigma, Sylvia Ferino-Pagden and Giovanna Nepi Scirè (eds.), Vienna/Milan 2004

OTHER PUBLICATIONS

Alpatow, Michail W., "Tizians 'Dornenkrönung'", in M. Alpatow, *Studien zur Geschichte der westeuropäischen Kunst*, Cologne 1974, pp. 65–94

Arasse, Daniel, *Tiziano. Venere d'Urbino*, Venice 1986

Aurenhammer, Hans H., *Tizian. Die Madonna des Hauses Pesaro. Wie kommt Geschichte in ein venezianisches Altarbild?*, Frankfurt am Main 1993

*Biadene, Susanna (ed.), *Titian. Prince of Painters*, Munich/New York 1990 (first published in conjunction with the exhibition at the Palazzo Ducale, Venice and National Gallery of Art, Washington 1990–91)

Bierwirth, Michael, *Tizians Gloria*, Petersberg 2002

Boehm, Gottfried, *Bildnis und Individuum. Über den Ursprung der Porträtmalerei in der italienischen Renaissance*, Munich 1985

Bohde, Daniela, *Haut, Fleisch und Farbe. Körperlichkeit und Materialität in den Gemälden Tizians*, Emsdetten-Berlin 2002

Caroli, Flavio and Stefano Zuffi, *Tiziano*, Milan 1990

Crowe, Joseph Archer and Giovanni-Battista Cavalcaselle, *Titian: His Life and Times*, two vols., London 1877

Feghelm-Aebersold, Dagmar, *Zeitgeschichte in Tizians religiösen Historienbildern*, Hildesheim 1991

Fehl, Philipp, 'The Worship of Bacchus and Venus in Bellini's and Titian's Bacchanals for Alfonso d'Este', in *Studies in the History of Art*, vol. 6, National Gallery of Art, Washington, D.C., pp. 37–59

Freedman, Luba, *Titian's Independent Self-Portraits*, Città di Castello 1990

Frings, Gabriele, *Giorgiones Ländliches Konzert. Darstellung der Musik als künstlerisches Prgramm in der venezianischen Malerei der Renaissance*, Berlin 1999

*Gentili, Augusto, *Da Tiziano a Tiziano. Mito e allegoria nella cultura veneziana del Cinquecento*, Milan 1980

Gentili, Augusto, *Tiziano*, Florence 1985

Ginzburg, Carlo, 'Titian, Ovid and Sixteenth-Century Codes for Erotic Illustration' in *Clues Myths and the Historical Method*, translated by John and Anne Tedeschi, Baltimore 1992, pp. 77–95

Giorgi, Roberta, *Tiziano. Venere, Amore e il Musicista in cinque dipinti*, Rome 1990

Goffen, Rona, *Titian's Women*, New Haven 1997

Goffen, Rona (ed.), *Titian's 'Venus of Urbino'*, Cambridge 1997

Hetzer, Theodor, *Tizian. Geschichte seiner Farbe*, Frankfurt am Main 1935

*Hope, Charles, *Titian*, London 1980

Hope, Charles, *Titian*, London 2004

Huse, Norbert and Wolfgang Wolters, *Venedig. Die Kunst der Renaissance. Architektur, Skulptur, Malerei 1460–1590*, Munich 1986

*Joannides, Paul, *Titian to 1518. The Assumption of Genius*, New Haven/London 2001 (addresses Titian's œuvre and environment up to 1518 and provides an indispensable basis for studying this otherwise poorly documented early period of his career)

Mancini, Matteo (ed.), *Tiziano e le Corti d'Asburgo, nei documenti degli Archivi Spagnoli*, Venice 1998

Marek, Michaela J., *Ekphrasis und Herrscherallegorie. Antike Bildbeschreibungen bei Tizian und Leonardo*, Worms 1985

*Meilman, Patricia (ed.), *The Cambridge Companion to Titian*, Cambridge University Press 2004

Mozzetti, Francesco, *Tiziano. Ritratto di Pietro Aretino*, Modena 1996

Nash, Jane C., *Veiled Images. Titian's Mythological Paintings for Philip II*, Philadelphia 1985

Neumann, Jaromír, *Tizian. Die Schindung des Marsyas*, Prague 1962

Oberhuber, Konrad, *Disegni di Tiziano e della sua Cerchia*, Venice 1976

Ost, Hans, *Tizian-Studien*, Cologne/Weimar/Vienna 1992

Panofsky, Erwin, *Problems in Titian, Mostly Iconographic*, New York 1969

Panofsky, Erwin, 'Titian's Allegory of Prudence: A Postscript', in *Meaning in the Visual Arts*, Chicago 1974, pp. 146–78

Panofsky, Erwin, 'The Neoplatonic Movement in Florence and North Italy (Bandinelli und Titian)', in *Studies in Iconology. Humanistic Themes in the Art of the Renaissance*, Oxford 1939, pp. 129–69

Pedrocco, Filippo, *Titian*, New York 2001 (lavishly illustrated, although the text does not always meet expectations)

Pertile, Fidenzio and Ettore Camesasca (eds.), *Lettere sull'arte di Pietro Aretino*. 3 vols., Milan 1957–60

Puttfarken, Thomas, 'Tizians Pesaro-Madonna, Maßstab und Bildwirkung' in *Der Betrachter ist im Bild. Kunstwissenschaft und Rezeptionsästhetik*, Wolfgang Kemp (ed.), Cologne 1985, pp. 62–90

Rosand, David, *Titian*, New York 1978

*Rosand, David (ed.), *Titian. His World and his Legacy*, New York 1982

*Rosen, Valeska von, *Mimesis und Selbstbezüglichkeit in Werken Tizians. Studien zum venezianischen Malereidiskurs*, Emsdetten-Berlin 2001

Suthor, Nicola, *Augenlust bei Tizian. Zur Konzeption sensueller Malerei in der Frühen Neuzeit*, Munich 2004

Tietze, Hans, *Tizian. Leben und Werk*, Vienna 1936

Tischer, Sabine, *Tizian und Maria von Ungarn. Der Zyklus der pene infernali auf Schloß Binche (1549)*, Frankfurt am Main 1994

Tiziano e Venezia. Convegno internazionale di studi a Venezia, Vicenza 1980

Walther, Angelo, *Tizian*, Leipzig 1978

Warnke, Martin, *Hofkünstler. Zur Vorgeschichte des modernen Künstlers*, Cologne 1985

*Wethey, Harold E., *The Paintings of Titian. Religious Paintings*, London 1969; (*Portraits*, London 1971; *Mythological & Historical Paintings*, London 1976)

Wethey, Harold E., *Titian and his Drawings*. Princeton 1987

Zapperi, Roberto, *Tiziano, Paolo III ei suoi nipoti. Nepotismo e ritratto di stato*, Turin 1990

Zeitz, Lisa, *Tizian, teurer Freund. Tizian und Federico Gonzaga. Kunstpatronage in Mantua im 16. Jahrhundert*, Petersberg 2000

Index

Numbers in italics refer to pages with illustrations

Front cover: *Bacchus and Ariadne* (detail), *c.* 1520–23, see p. 63
Back cover: *Flora* (detail), *c.* 1515, see p. 91
Page 2: *Woman with a Fruit Bowl*, 1555
Page 4: *Venus Blindfolding Cupid* (detail), 1565, see p. 135

The Library of Congress Cataloguing-in-Publication data is
available; British Library Cataloguing-in-Publication Data:
a catalogue record for this book is available from the British
Library; Deutsche Bibliothek holds a record of this publication
in the Deutsche Nationalbibliografie; detailed bibliographical
data can be found under: http://dnb.ddb.de

Prestel Verlag, Munich
A member of Verlagsgruppe Random House GmbH

Prestel Verlag
Neumarkter Straße 28, 81673 Munich
Tel. +49 (89) 41 36-0
Fax +49 (89) 41 36-23 35

Prestel Publishing Ltd.
4, Bloomsbury Place, London WC1A 2QA
Tel. +44 (020) 7323-5004
Fax +44 (020) 7636-8004

Prestel Publishing
900 Broadway, Suite 603, New York, N.Y. 10003
Tel. +1 (212) 995-2720
Fax +1 (212) 995-2733

www.prestel.com

© Prestel Verlag, Munich · London · New York 2006,
special edition 2012

Translated from the German by Ishbel Flett, Edinburgh
Copy-edited by Christopher Wynne

Design and layout: Andrea Mogwitz, Munich
Origination: Repro Ludwig, Zell am See, Austria
Printed and bound by Druckerei Uhl GmbH & Co. KG, Radolfzell

FSC
www.fsc.org
MIX
Paper from
responsible sources
FSC® C004229

Verlagsgruppe Random House FSC®-DEU-0100
The FSC®-certified paper *Hello Fat Matt 1,1* has been
supplied by Condat, Le Lardin Saint-Lazare, France.

Printed in Germany

ISBN 978-3-7913-4697–7

Photographic Credits

The illustrations in this publication have been kindly
provided by the museums, institutions and archives
mentioned in the captions, or taken from the Pub-
lisher's archives, with the exception of the following:

akg-images, Berlin: front cover and pp. 12, 17, 63, 75,
95, 113, 115
Artothek, Weilheim: pp. 19, 20, 92, 127 (bottom left),
131 (top left),
– Alinari: pp. 81, 131 (centre, left)
– Dalibor Kusák: p. 110
– Josef S. Martin: pp. 84/85
– Peter Willy: pp. 6, 24, 26/27, 78
– Paolo Tosi: pp. 14, 86/87
© Bildarchiv preußischer Kulturbesitz (bpk), Berlin
2006; photographs: Jörg P. Anders: pp. 20, 118
The Bridgeman Art Library: pp. 9, 11, 23, 29/30, 32,
34, 36/37, 45, 46/47, 52/53, 60, 65, 68, 118, 123 (top),
125 (bottom), 134 (bottom), 135 (bottom right)
© Scala, Florence 2006: p. 101